A View of the Bay
COLLINGWOOD AND BEYOND

A View of the Bay
COLLINGWOOD AND BEYOND

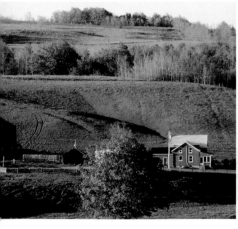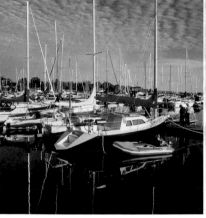

JOHN DE VISSER & JUDY ROSS

The BOSTON
MILLS PRESS

Published by Boston Mills Press, 2008
132 Main Street, Erin, Ontario N0B 1T0
Tel: 519-833-2407 Fax: 519-833-2195

In Canada:
Distributed by Firefly Books Ltd.
66 Leek Crescent
Richmond Hill, Ontario, L4B 1H1

In the United States:
Distributed by Firefly Books (U.S.) Inc.
P.O. Box 1338, Ellicott Station
Buffalo, New York 14205

First printing

The publisher gratefully acknowledges for the financial support for our publishing program
by the Government of Canada through the Book Publishing Industry Development Program.

Library and Archives Canada Cataloguing in Publication

De Visser, John, 1930–
A view of the bay : Collingwood and beyond / photographs by John de Visser ; text by Judy Ross.

ISBN-13: 978-1-55046-491-7 ISBN-10: 1-55046-491-4

1. Collingwood Region (Ont.) — Pictorial works. 2. Collingwood Region (Ont.) —
History. 3. Collingwood Region (Ont.) — Description and travel. I. Ross, Judy, 1942– II. Title.

FC3095.C676D4 2008 971.3'17 C2008-901571-1

Publisher Cataloging-in-Publication Data (U.S.)

De Visser, John, 1930–
A view of the bay : Collingwood and beyond / photographs by John de Visser ; text by Judy Ross.

[160] p. : col. photos. ; cm.
ISBN-13: 978-1-55046-491-7 ISBN-10: 1-55046-491-4

1. Collingwood (Ont.) — Pictorial works. 2. Collingwood (Ont.) — History. 3. Collingwood (Ont.) —
Description and travel. I. Ross, Judy Thompson, 1942– . II. Title.

971.1317 dc22 F1059.5.C65D415 2008

Design by Gillian Stead
Edited by Ruth Taylor

Printed in China

for Sandra

JOHN DE VISSER

for Robbie, Noelle and Doug, Aimee and Ian, Luke, Tyler and Molly — my inspiring family

JUDY ROSS

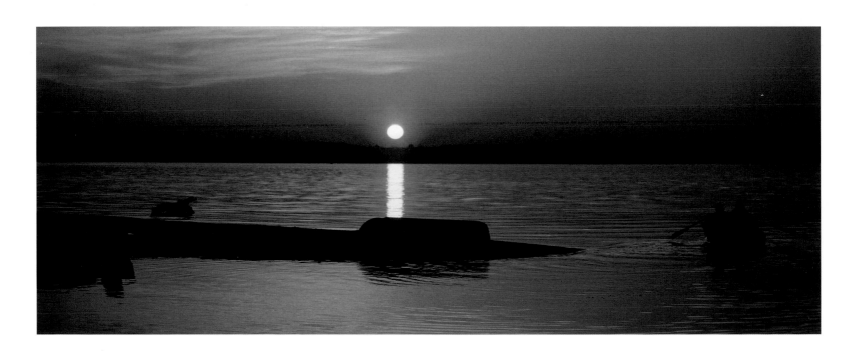

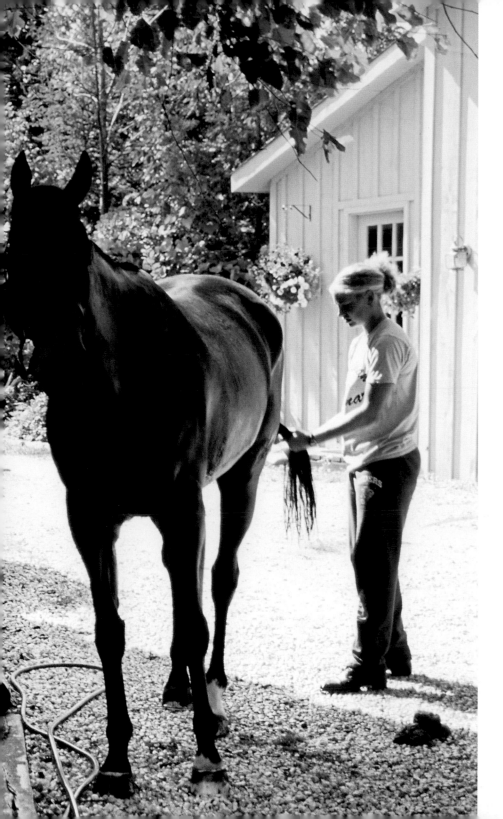

A View of the Bay
COLLINGWOOD AND BEYOND

Abe gets a bath at the back door of the Franks' stone farmhouse near Duntroon.

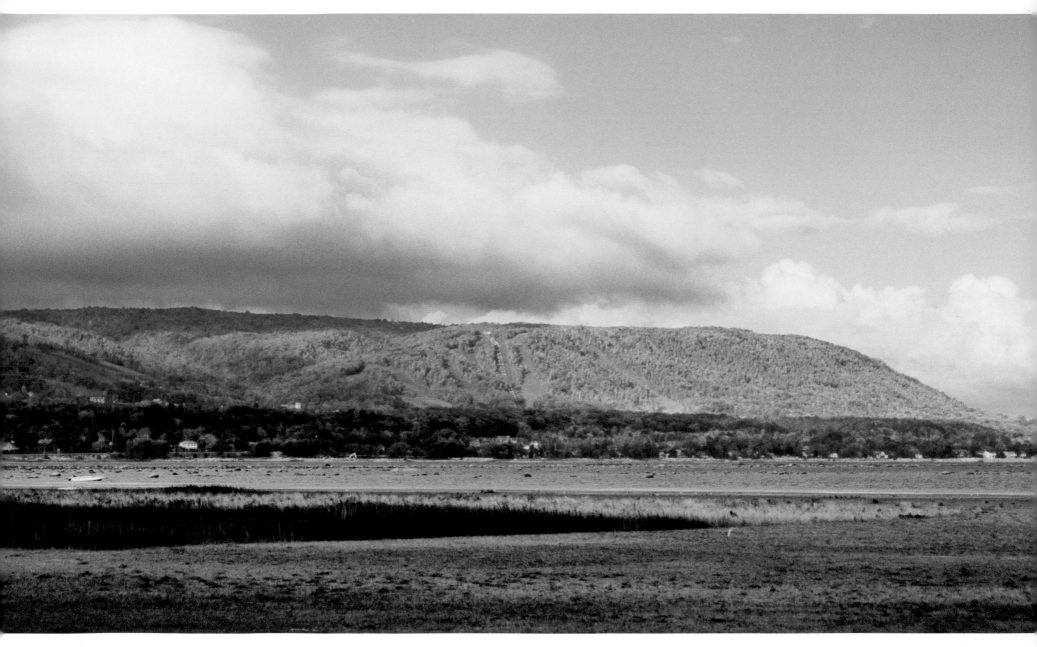

The portion of the Niagara Escarpment known here as the Blue Mountains rises to the west of the town of Collingwood. In winter the cleared patches etched on the escarpment face are downhill ski runs.

Life on the Edges of the Bay

I T IS NEARING MIDNIGHT on a cold night in February. The moon is full and I can see my breath in the clear air as I clomp through knee-high snow across a farmer's field. On my feet are a pair of newly purchased snowshoes. Ahead of me, a single line of fellow clompers, gamely trudging along moonlit tracks, their dark bundled figures like characters in an Ingmar Bergman movie.

It is well past the time we're usually all in bed. The air is tart with frost that tickles the back of my throat. Moon shadows lengthen across fields that, in summer, will be thick with hay — and in the distance the town lights of Collingwood twinkle like a mirage. Beyond that, the half-frozen edges of Georgian Bay. After an hour or so of crossing hill and dale, we will wend our way back to a cozy fieldstone farmhouse and settle our weary bones for brandy by the fire.

We are newcomers, recent arrivals from the city, and have quickly been swept into the range of year-round outdoor pleasures that have become part of life in southern Georgian Bay.

For many of us who have moved to this corner of the country (and especially for those born here), there's an implicit sense that this is unique. We are blessed with a dramatic limestone ridge, the Niagara Escarpment, which provides us with hiking trails, conservation areas and, most importantly, ski hills. In Ontario this is the closest thing we have to mountains, and we take full advantage of it. The first ski tow was put up in the 1930s by the Blue Mountain Ski Club, and now hundreds of runs and a multitude of high-speed chairlifts slice across the Escarpment face from Devil's Glen to Georgian Peaks.

For those who prefer to stay at ground level, there's a waterfront trail that links the south shore

towns of Meaford, Thornbury and Collingwood. The much-used Georgian Trail is an abandoned Canadian National Railway line that loops across 32 kilometres (20 mi) through orchards and woodlands. This wide gravel path, initiated and still maintained by local citizens, is ideal for walking and biking and, in winter, snowshoeing and cross-country skiing. In spring, around the Craigleith Depot (once the railway terminal for the ski train from Toronto's Union Station), dozens of lilac bushes edge the trail, making for a sweetly perfumed outing. And across the way is a wide-open view of Georgian Bay.

We are surrounded by water here. Nottawasaga Bay, an immense body of fresh water, forms the most southerly loop of Georgian Bay. It spreads across 75 kilometres (46.5 mi) of coastline from Meaford to Wasaga Beach, with Collingwood Harbour placed strategically at its deepest point. Fanning out southward from the water are meadows and valleys with the most fertile land in Ontario. The lush area known as the Purple Hills boasts rivers with bluntly descriptive names — Mad, Noisy, Pretty. All of them weave through stunningly beautiful landscape.

At Wasaga the shore flattens to wide hard-packed sand, 14 kilometres (8.5 mi) of it, forming the longest freshwater beach in the world. Water is never far away — either literally or emotionally. It forms a large part of our psyche. As well as the vast shoreline of the bay, there are three mighty rivers that empty into it: the Bighead at Meaford, the Beaver at Thornbury and the Nottawasaga at Wasaga Beach.

The combination of the bay, rivers and valleys and of the looming backdrop of the Niagara Escarpment lures weekenders and vacationers and a growing number of artists who live and work here year-round — photographers, potters, painters, musicians, writers — all of whom find their muse in the lilting landscape. As a 1950 promotional booklet called *Know Collingwood* gushingly declared, "To have lived in the shadow of the Blue Mountains and in the clear air of Georgian Bay is to retain forever a sense of beauty and of grace."

When it comes to living here, there are countless options suited to any lifestyle. The shoreline — in places, boulder strewn; in others, sand covered — for those who love water; hills and valleys for secluded country retreats; fertile fields for anyone yearning to

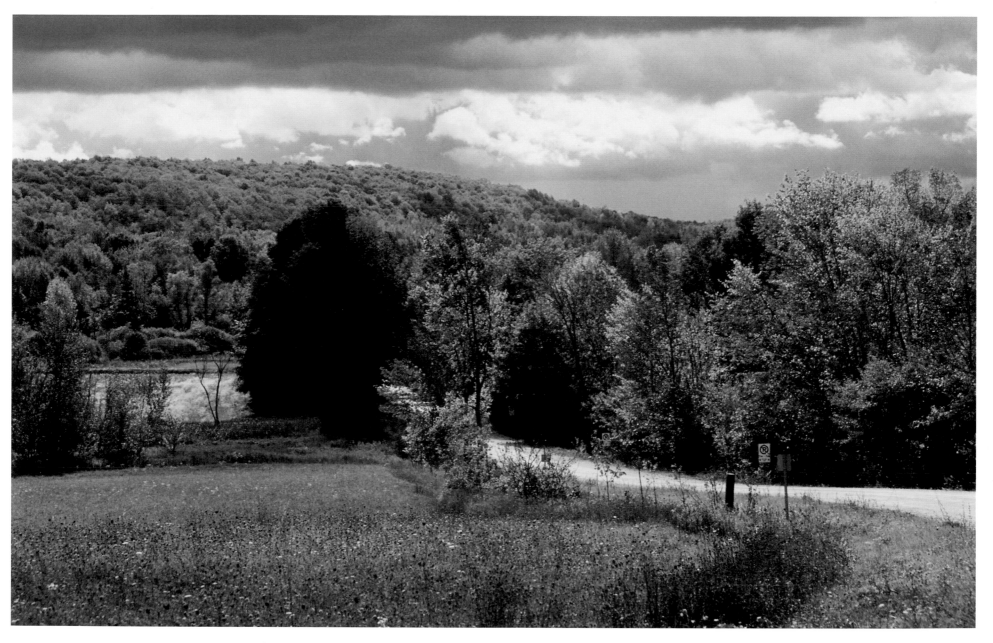

Autumn in the Beaver Valley which spreads south from Thornbury and follows the meandering Beaver River.
The valley forms part of a UNESCO World Biosphere Reserve.

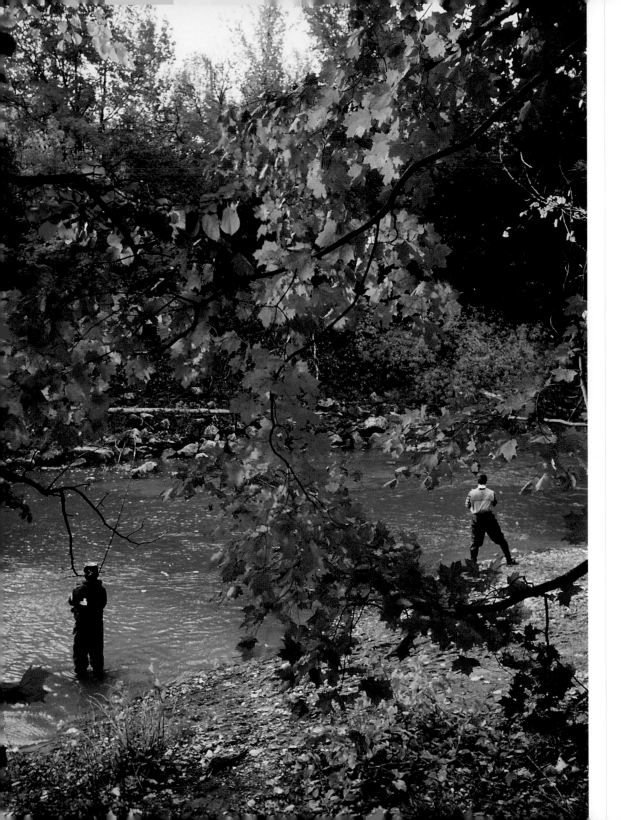

farm the land; condos for easy living, on golf courses and the waterfront; the Village at Blue for resort-style life; and for those interested in local heritage, historic towns and villages featuring downtown neighbourhoods lined with vintage red brick homes. In new subdivisions houses pop up like dandelions on a spring lawn, and along concession roads, what once was farmland is giving way to lavish country spreads with mega mansions and million-dollar views.

The views. They exist because of the happy convergence of water and mountain. Ask any hiker about the best scenic outlooks, or any skier where he pauses, and rests on his ski poles, to take it all in. Newcomers build their hilltop aeries and angle them just so to capture the panorama. But sometimes a view happens when least expected. Drive up a concession road heading north from Creemore, crest a hill — and suddenly there's Georgian Bay, a blaze of blue beyond the farm pastures and woodlands. It's a breathtaking sight — especially at sunset, when sky and water

Anglers cast for fish
during the fall spawning run in the Bighead River.

spread across the horizon, melding together in every shade of red and orange.

Every season comes with its own cause for celebration. In spring, skiers are still dancing through the last bit of snow that clings to the slopes, and apple blossom tours take place in the countryside. In rivers and along the shale beaches, anglers cast about for salmon and lake trout. Come summer, the clear turquoise bay waters, as inviting as the Caribbean, beckon weekenders and vacationers for beach parties and boating. The golf courses come alive, cyclists take to the trails and roads, outdoor patios spill over with revellers. In fall, the farms offer up their bounty at markets in every town and village. Harvest tours through apple country give everyone a chance to bite into a freshly picked apple.

And on winter nights when the air is crisp and the moon is full, someone, somewhere, will be hosting a midnight snowshoe party.

An old Ontario farmhouse
with traditional brickwork and gingerbread gable trim.

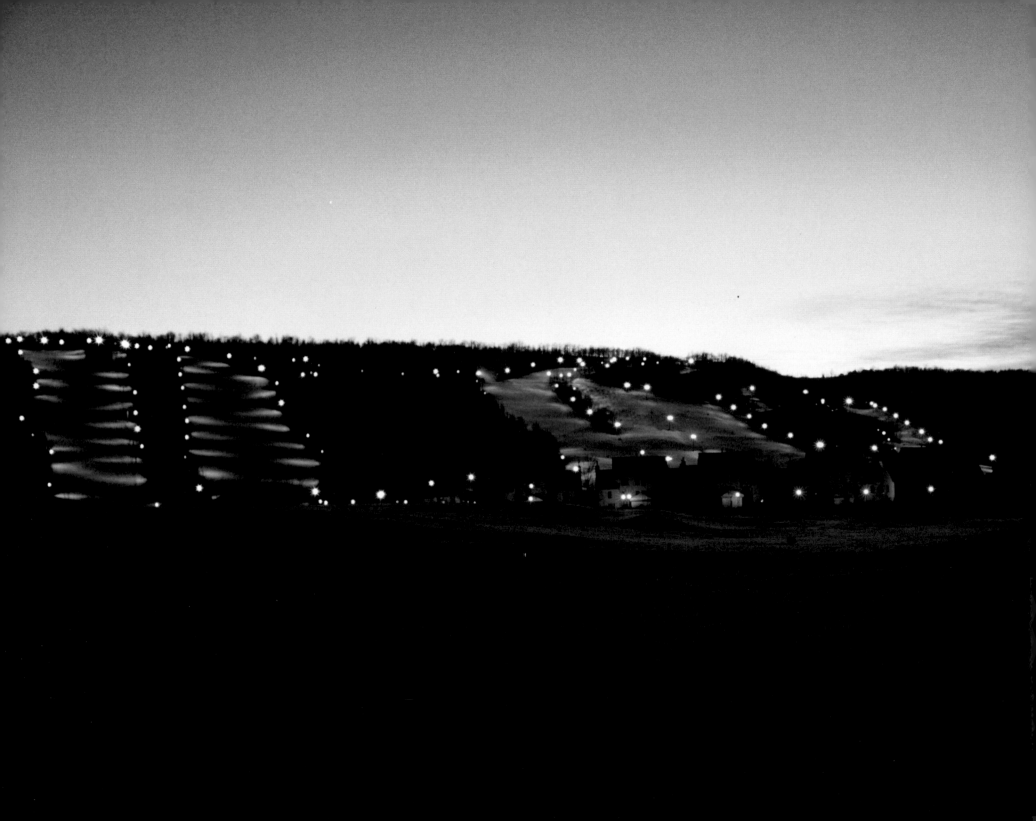

Blue Mountain lit up for night skiing.

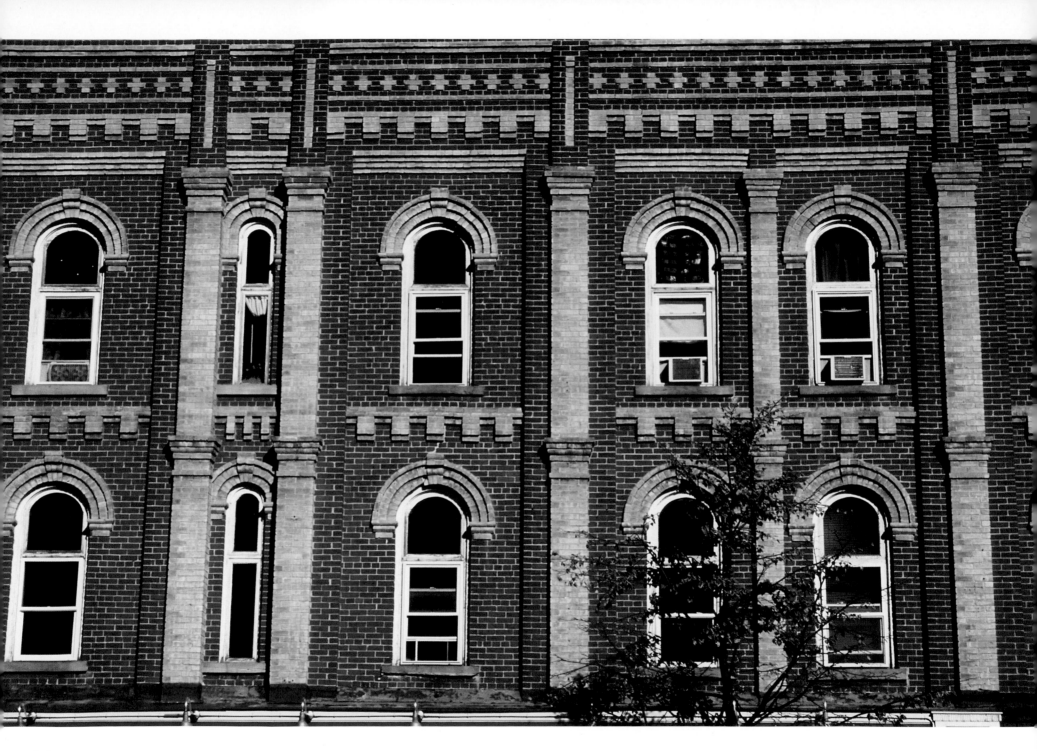

The heritage brick buildings on Hurontario Street in Collingwood were built between 1880 and 1930.

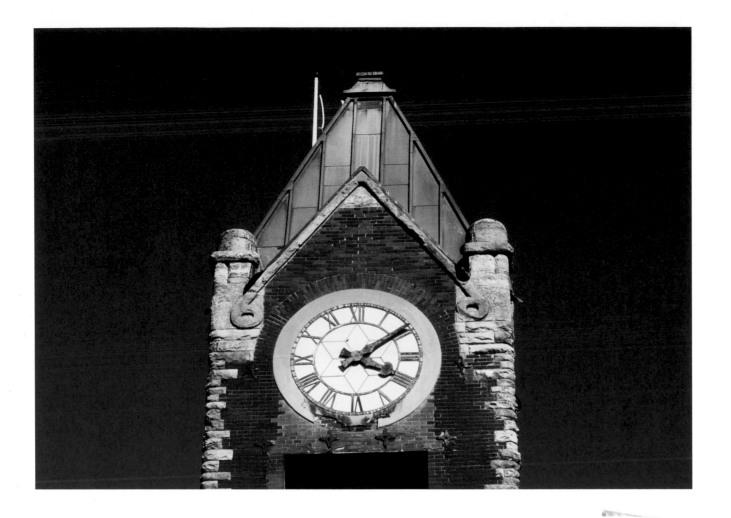

ABOVE: *The Collingwood town hall was built in 1889 of pressed brick and sandstone.*
Its clock tower, added in 1950, is a landmark on the town's main street.

RIGHT: *Construction of the new Village at Blue at the base of the ski hills began in 1999,*
its buildings designed to replicate old Ontario architectural style.
It provides a lively year-round centre of activity at the resort.

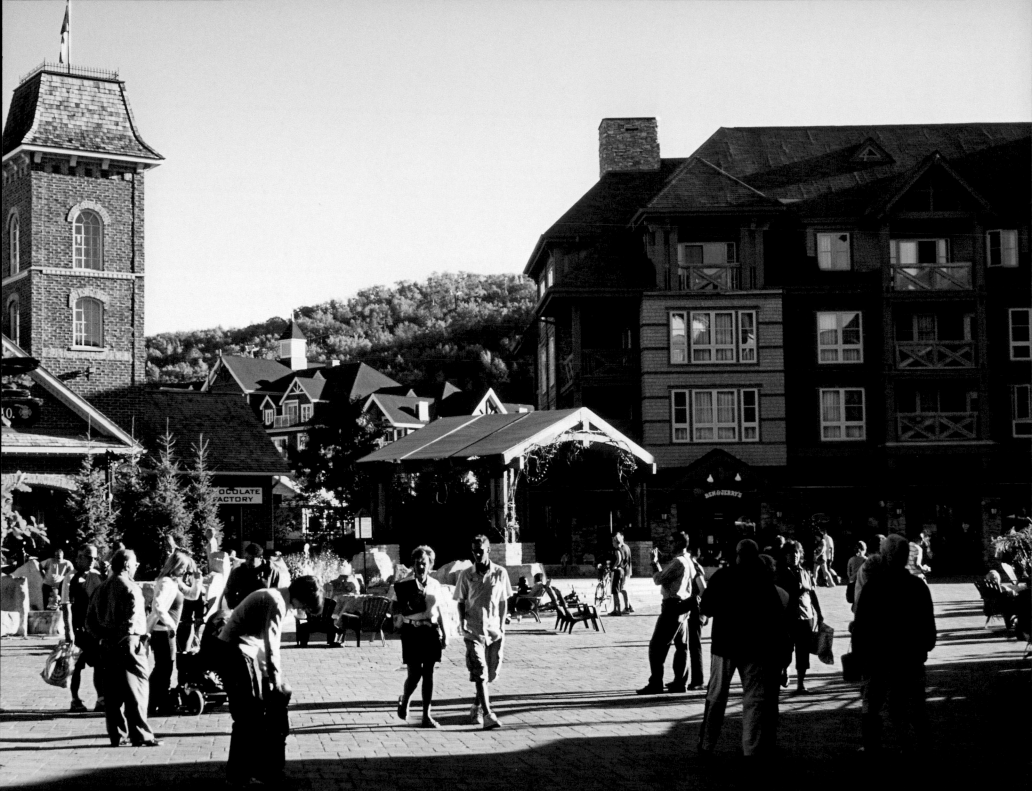

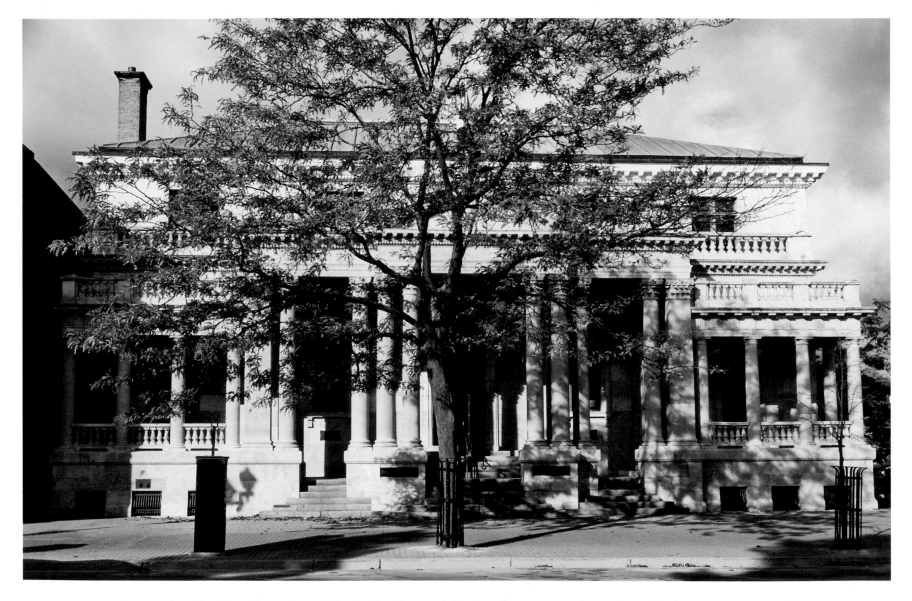

ABOVE: *Collingwood's Federal Building, designed by local architect Philip C. Palin in 1913. The regal marble facade and stately columns were reportedly inspired by the State Finance building in Havana, Cuba. Inside, a stained glass dome soars over the rotunda.*

OPPOSITE: *Sunset on a calm evening on Georgian Bay. Samuel de Champlain named it "La Mer Douce" (the freshwater sea) when he visited in 1615.*

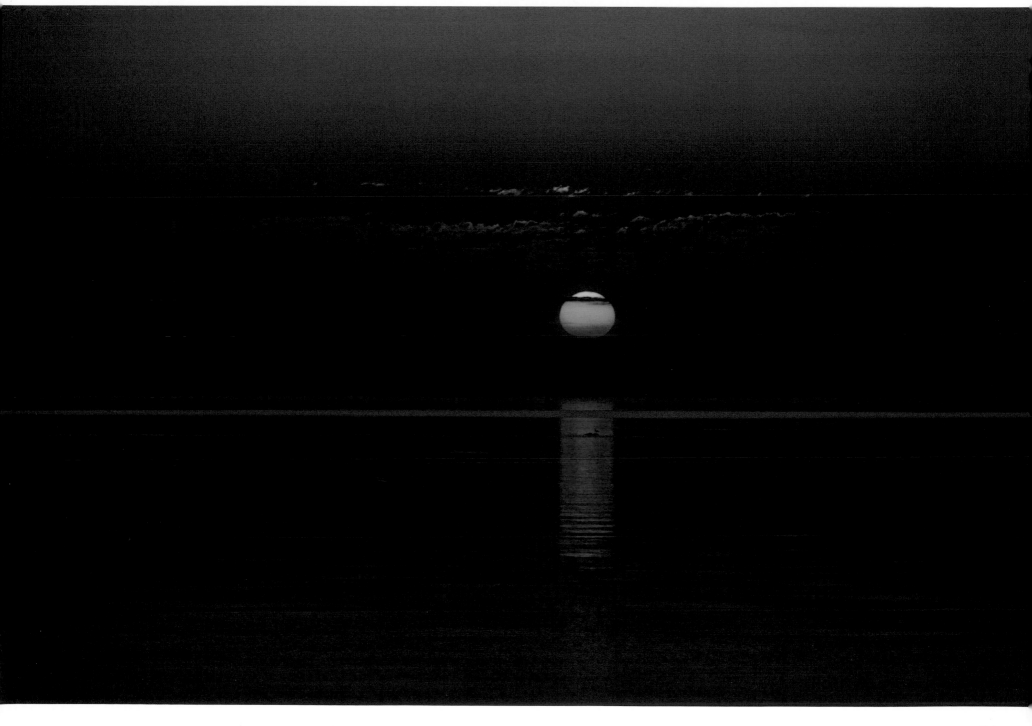

A New Name

<div style="text-align: right">1</div>

On looking out, I saw a range of wood-covered hills, a saw-mill, and several plank-houses, the principal one a large store which had suddenly arisen on the forest-shore. To the left we could distinguish the long cutting through the forest, made for the railway, which already reaches down to the water; and to the right were the rocks, called the Hen and Chickens, said to constitute it a safe harbour.

William H. G. Kingston, an Englishman, seeing Collingwood by steamer in 1853

I N 1853 COLLINGWOOD was not even a village, merely a gathering of primitive shacks, as our English traveller observed as he cruised past. By this time steamboats had been plying the waters of Georgian Bay for over 20 years. Any recorded diaries of these journeys are riddled with tales of battering storms, poorly constructed vessels and unhappy shipmates. Kingston, travelling with his wife, had boarded the *Kaloolah*, a 188-foot sidewheel steamer, at Sturgeon Bay and was bound for Sault Ste. Marie, with stops planned at various settlements along the way, including the future town of Collingwood.

The cluster of rocks or islands (one large and several smaller) that he noticed had given the harbour its name, Hen and Chickens. And the train tracks that he could see in the making would soon bring the railway and change the course of history for this newly formed settlement.

The railway, in the form of a wood-burning locomotive, arrived in 1855 and was named the Ontario, Simcoe & Huron Railway, although the local settlers called it the Oak, Straw & Hay, a playful reference to its primary cargo. The pioneers, proud of their new status as the northern terminus of this brand new form of locomotion, decided that their town needed a more

The huge white columns of the Collingwood Terminals, built in 1929. Used for storing grain in the days when the harbour was a busy shipping centre, now they're a nostalgic landmark.

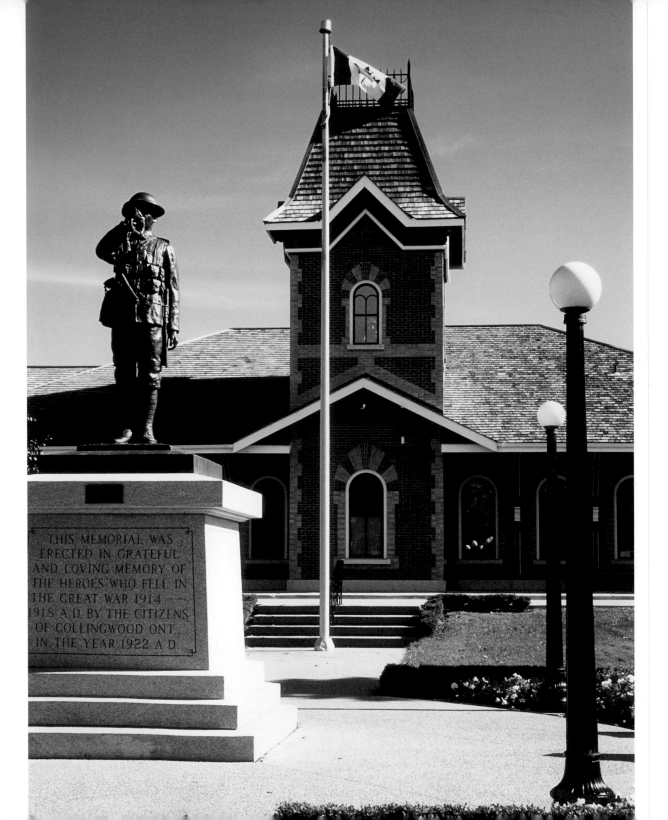

THIS MEMORIAL WAS
ERECTED IN GRATEFUL
AND LOVING MEMORY OF
THE HEROES WHO FELL IN
THE GREAT WAR 1914 —
1918 A D BY THE CITIZENS
OF COLLINGWOOD ONT.
IN THE YEAR 1922 A D

A World War I soldier atop the cenotaph erected in 1922. The memorial stands in front of the reconstructed railway station that houses the Collingwood Museum.

dignified name than Hen and Chickens. This was pre-Confederation: the country was still a British colony and much in awe of the heroic military feats and naval battles taking place on the other side of the Atlantic. Free land grants were liberally handed out to retired military and naval men as a thank you for their services. Few of them ever crossed the ocean to see their land.

And the naval man whose name would become forever linked with this Georgian Bay settlement had already died. Admiral Lord Cuthbert Collingwood was Lord Horatio Nelson's second-in-command at the Battle of Trafalgar. Although that battle had taken place 50 years earlier in 1805, it still resonated in the colonies as a military coup. Lord Collingwood, somewhat of an unsung hero except in parts of northeastern England (where he was born), took over command of the British fleet after Nelson's death. He completed the battle, saw the defeat of Napoleon and then, five years later, died at sea and was buried next to Nelson in St. Paul's Cathedral in London.

On January 1, 1858, the town officially became Collingwood, and the name Hen and Chickens faded into history.

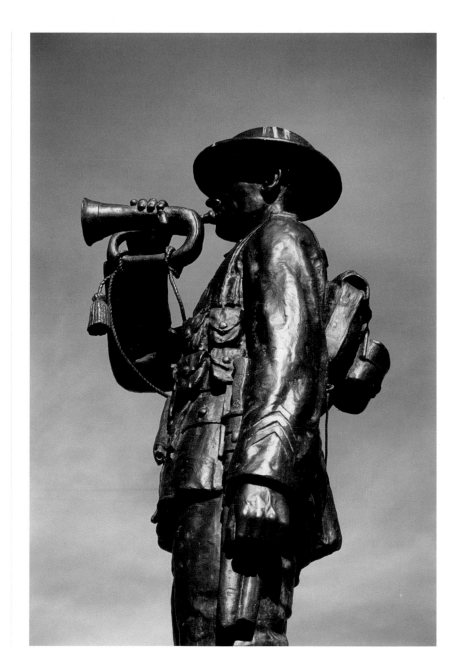

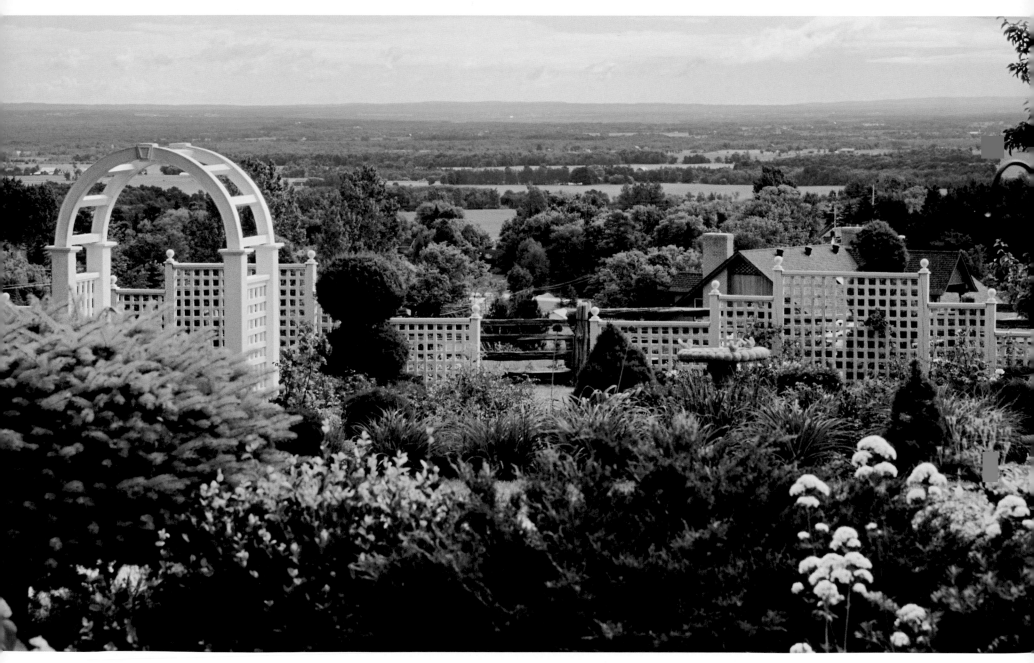

A series of lattice screens and arches create interesting focal points in a hilltop Victorian garden with a long view.

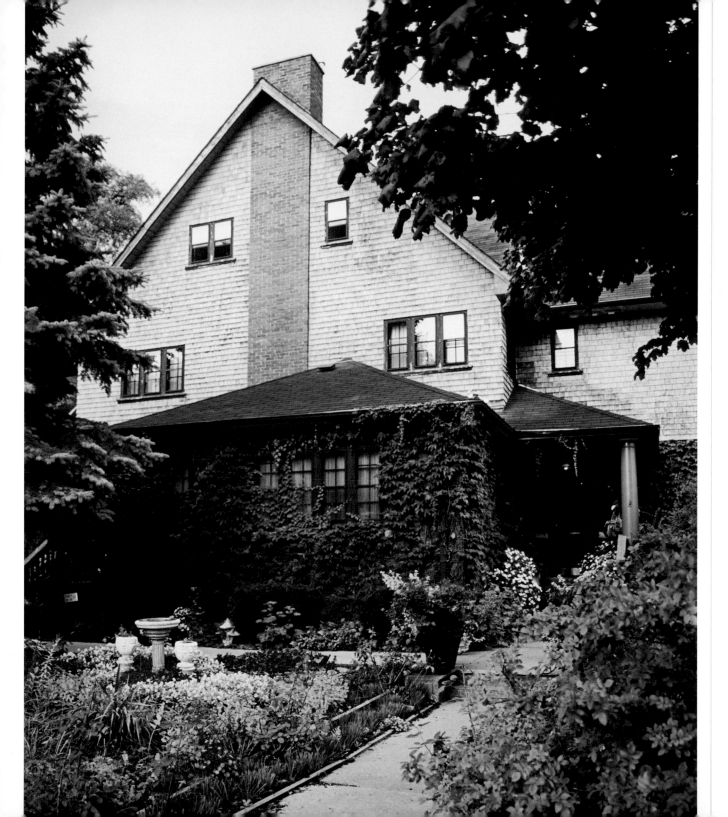

The Bield House Country Inn & Spa, designed by famed Toronto architect Eden Smith. The 11-room English country style inn is on Third Street in Collingwood's heritage neighbourhood.

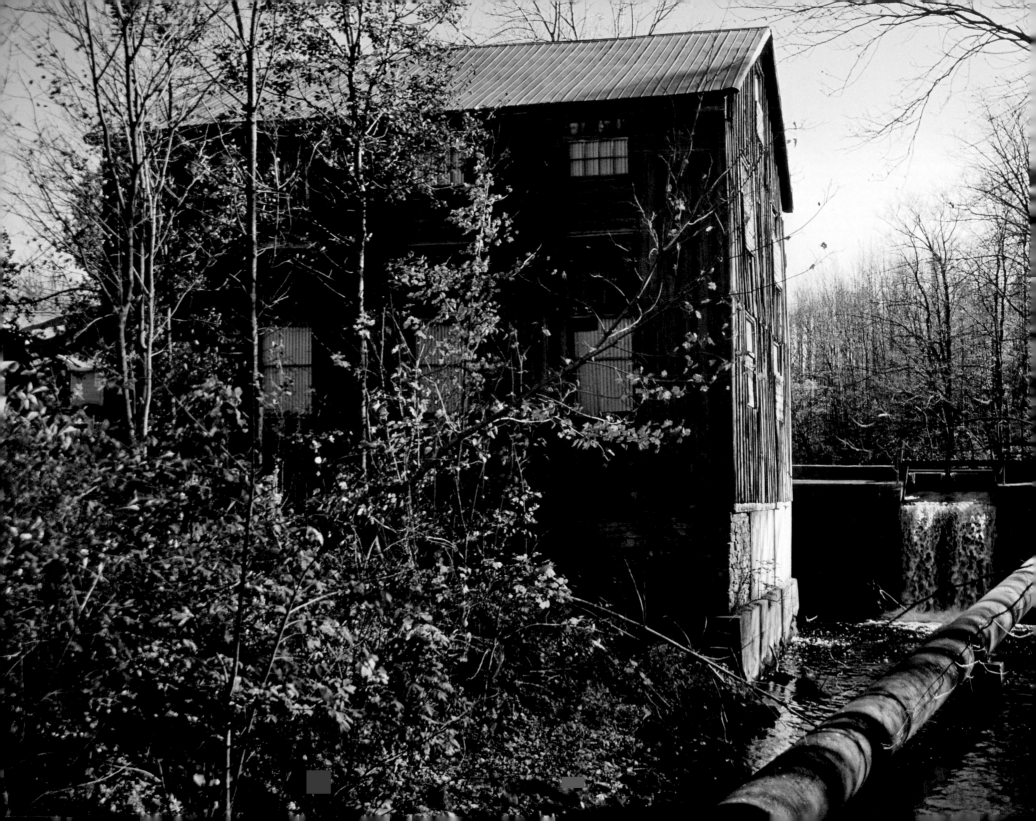

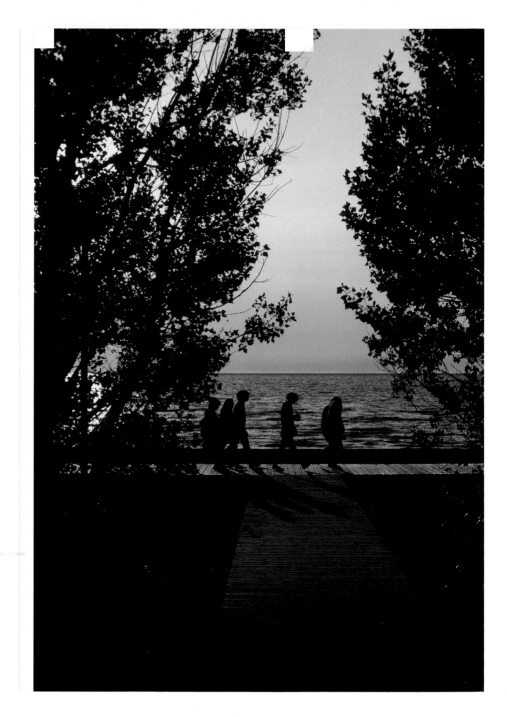

RIGHT: *Late afternoon on the wooden boardwalk at Wasaga Beach, a 14-kilometre-long (8.5mi) stretch of sand.*

LEFT: *The old mill at Walters Falls, where water tumbles over the Niagara Escarpment into the Bighead River valley.*

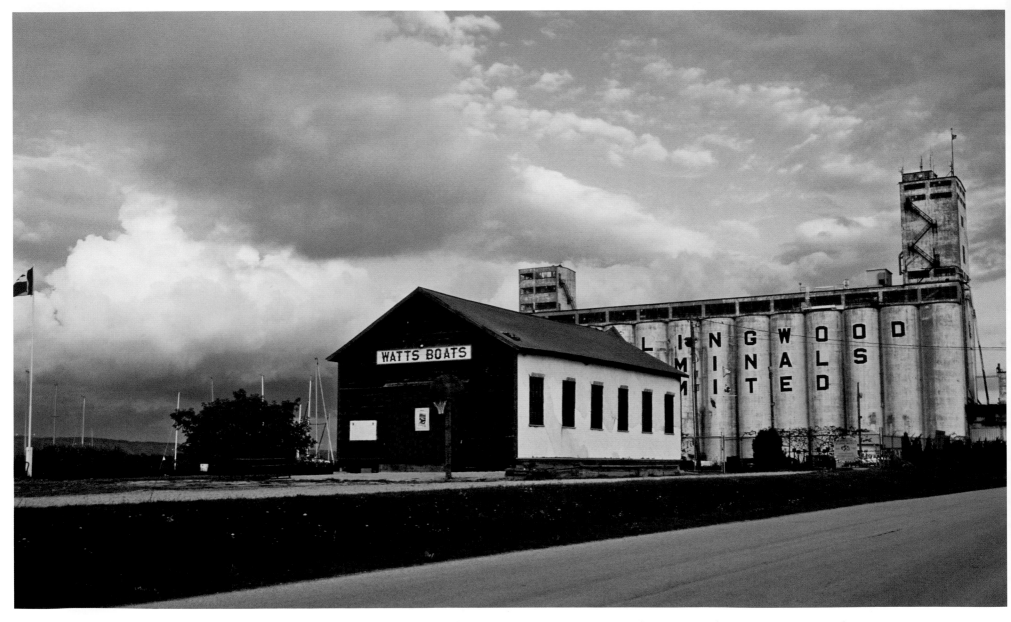

Watts historic boathouse, built in 1850, was moved from its original location on Maple Street North to Harbourlands Park. William Watts and his family built boats here for over 135 years. Their most famous product was the "Collingwood Skiff," a two-ended sailing ship that performed reliably in the rough waters of Georgian Bay.

Last Launch at "The Yard"

APRIL **18, 1985.** A massive cargo ship sits like a fortress at the end of Hurontario Street, Collingwood's main street. It's such a common sight in this town that people hardly notice its hulking presence. For over 100 years, ships have been built here, and barely a day has passed when there wasn't one rising above the water at that dock. But this day is special. The *M. V. Paterson*, a 20,000-ton bulk carrier, is going to be launched, and everybody in town knows it. Collingwood is the only shipyard in Canada to side-launch its vessels — and it is always a crowd-pleasing spectacle.

Parents collect their kids from school to take them down to the waterfront. Offices close early so employees can be part of the excitement. People climb on top of parked cars to get a good view. Television crews come up from Toronto, and on every nearby rooftop, crowds are gathering.

The shipyard workers, about 1,200 strong, are as excited as children who have finally finished building a model ship. They've been gearing up for this day ever since the work began on the large steel freighter just five months earlier. At the Yard, as it is called, 600 of these workers are now pounding 8,000 wooden wedges beneath the ship, building a platform for her to slide from. As they swing their mallets, a pipe band is leading a crowd of dignitaries to the launching platform, built specially for the occasion and draped in red, white and blue satin. Miss Ellen Paterson, daughter of the man who commissioned the ship, is there in her frothy white hat, about to perform the "christening" by flinging a bottle of champagne tied to a rope against the ship's bow.

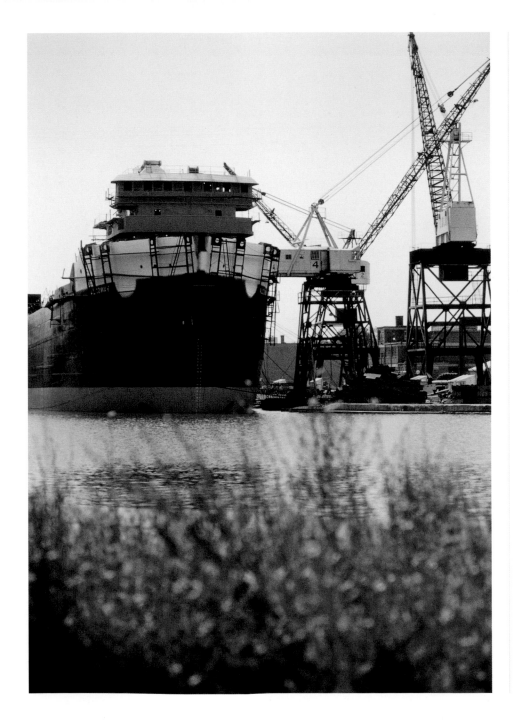

A band plays "O Canada"; the minister of the Presbyterian Church offers a prayer to bless the ship on her launching day; the champagne bottle, wrapped in red, white and blue ribbons, cracks against the bow and bursts; the warning blast sounds; the launch master orders the ropes to be cut and the 224-metre (736.5 ft) *M. V. Paterson* slides sideways off the wooden timbers into a slip not much wider than the ship herself. Her 20,000 tons hit the water creating a tsunami. Water sprays everywhere, and in seven seconds it is all over.

Long before Collingwood became known for its ski resorts, it was known all over North America as a shipbuilding town. The Collingwood Dry Dock Shipbuilding and Foundry Company was established in 1883, and then, when steel replaced wood as the predominant building material, it became the Collingwood Steel Shipbuilding Company. The first steel ship, the 308-foot 200-passenger *Huronic,* was launched in 1901 as Hull Number 1. The *M. V. Paterson* is Hull Number 231.

A laker under construction at "The Yard"
in Collingwood in the late 1970s.

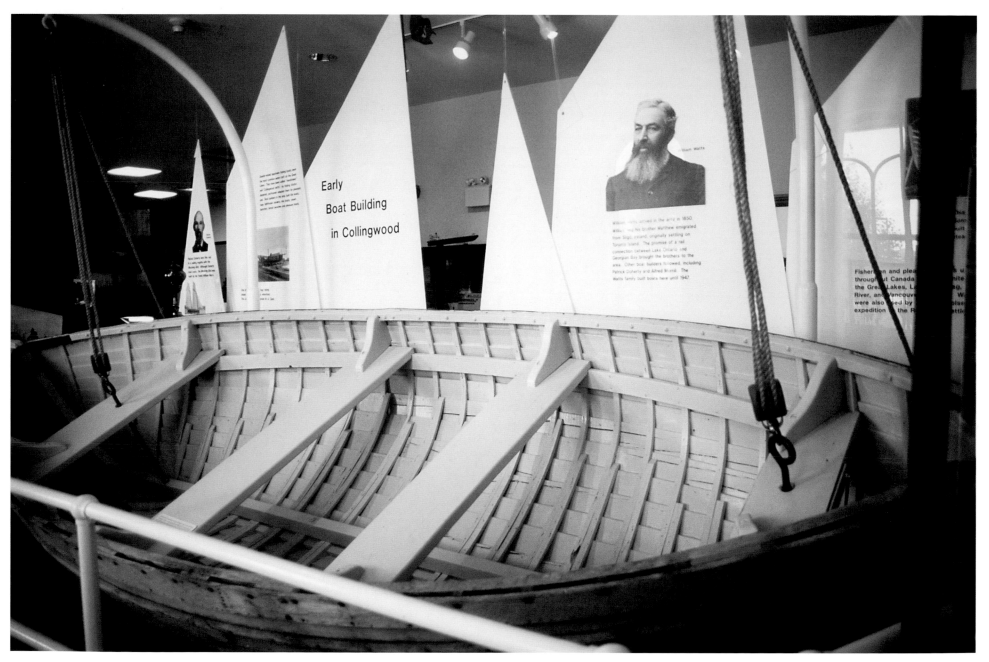

Historic boat exhibit at the Collingwood Museum.

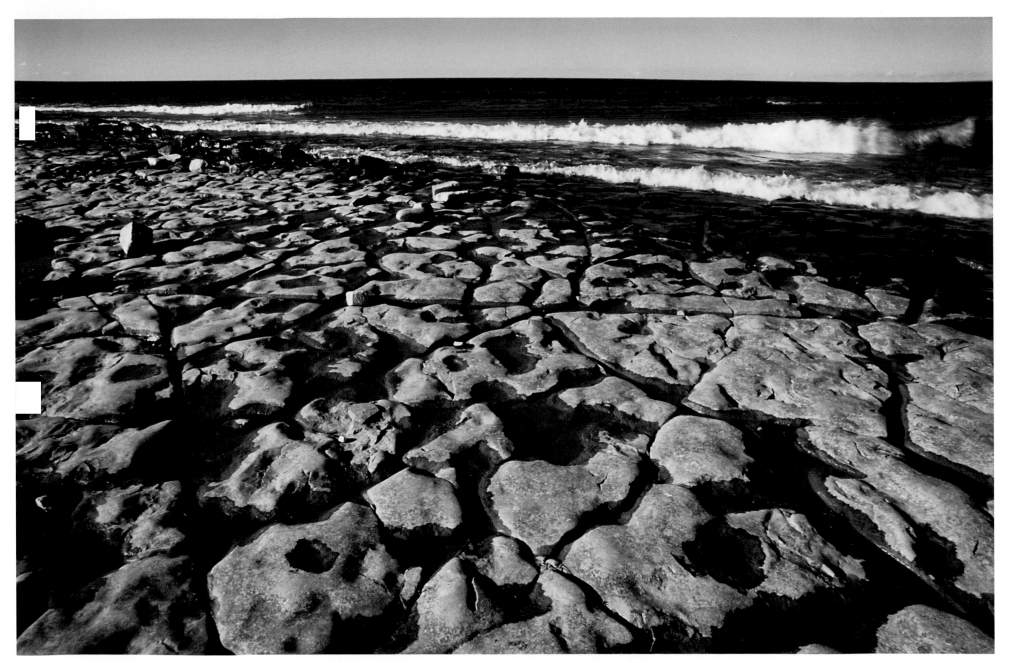

The shale shoreline at Craigleith Provincial Park.

Two or three large ships a year was the average output. During two world wars, the shipyards continued to operate. Production in World War II included corvettes, armed trawlers and mine sweepers. In peacetime the Yard produced tankers, passenger ships, barges, tugs, trawlers, ferries, icebreakers, sightseeing boats and, most frequently, self-unloaders and bulk freighters like the *M. V. Paterson*.

Among the politicians and dignitaries on the launch platform back in April 1985 was the head of the electrical department, Chic Simonato. Now 84 years old, he reminisces about that day while sitting in his Collingwood home among a collection of shipyard memorabilia: "It was exciting, but there was a sense of doom," he recalls. "Rumours of the shipyard's closing had been going around, and the market for Great Lakes ships was coming to an end. We knew it was just a matter of time."

It was. The *M. V. Paterson* was the last ship to be built, launched and christened in Collingwood, and the Yard closed forever on September 12, 1986. Chic, who had collected mementos during his 40 years of employment there, says, "It was a sad, sad day. I still remember every minute of it when they announced the closing."

Among the many treasures in his basement is the long rope, still strung with red, white and blue ribbons, that was attached to the champagne bottle that Miss Paterson flung at the ship on that warm spring day in 1985.

A relic from the shipbuilding era, at Harbourlands Park.

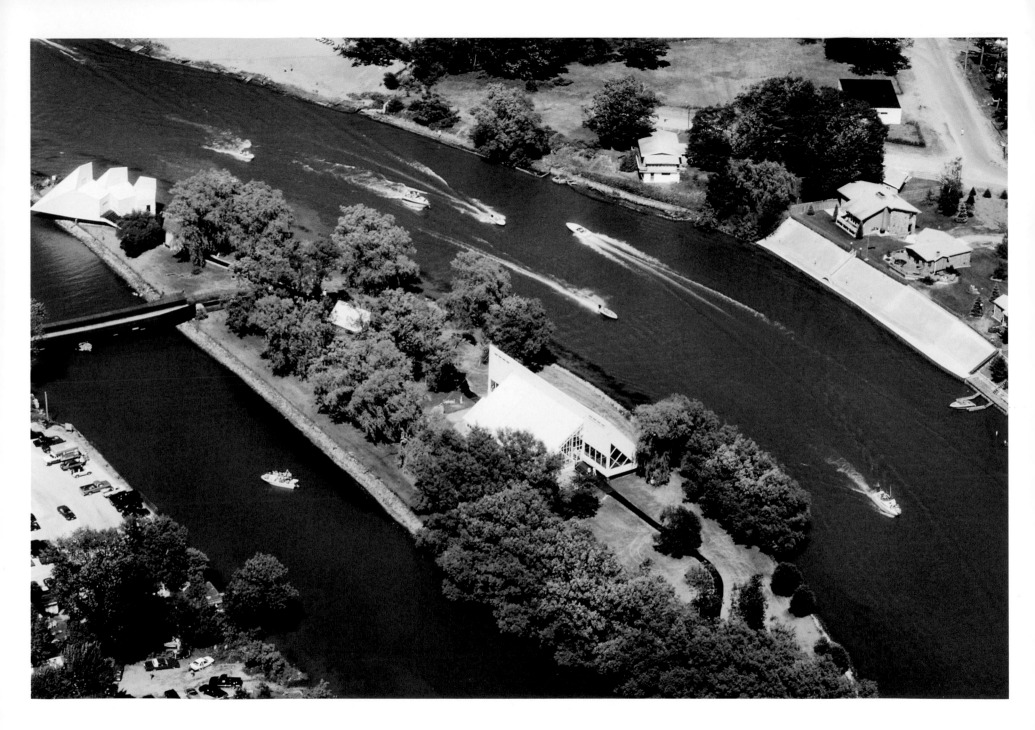

ABOVE: *A peek at grand mansions on tree-lined Third Street in Collingwood.*

OPPOSITE: *The Nancy Island Historic Site on the Nottawasaga River. The museum contains the remains of the HMS Nancy, a schooner used as a British supply ship in the War of 1812. She was destroyed by American forces, and her sunken hull created an obstruction in the river, which then formed an island.*

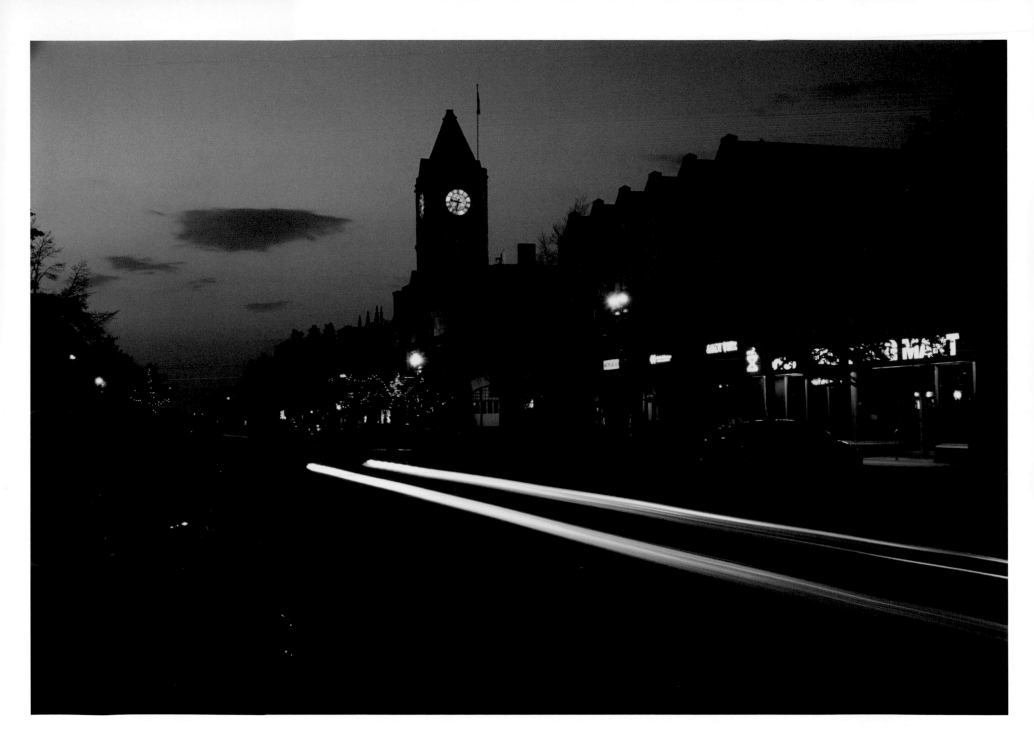

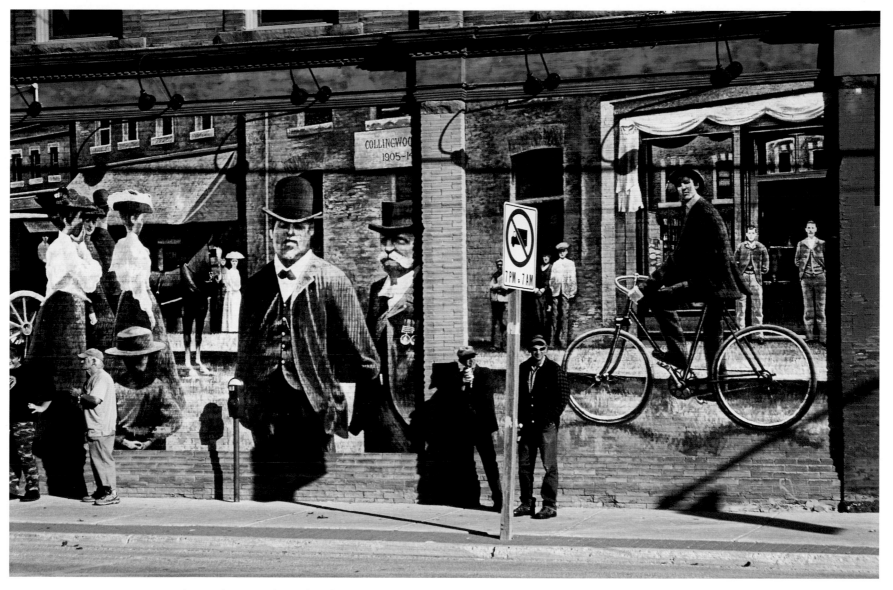

ABOVE: *Several murals grace the walls of buildings in downtown Collingwood. This is a detail of one, titled* Busy Wagons, *at the corner of Second and Hurontario. It was painted, using archival photographs, by artist John Hood.*

OPPOSITE: *Hurontario Street after dark.*

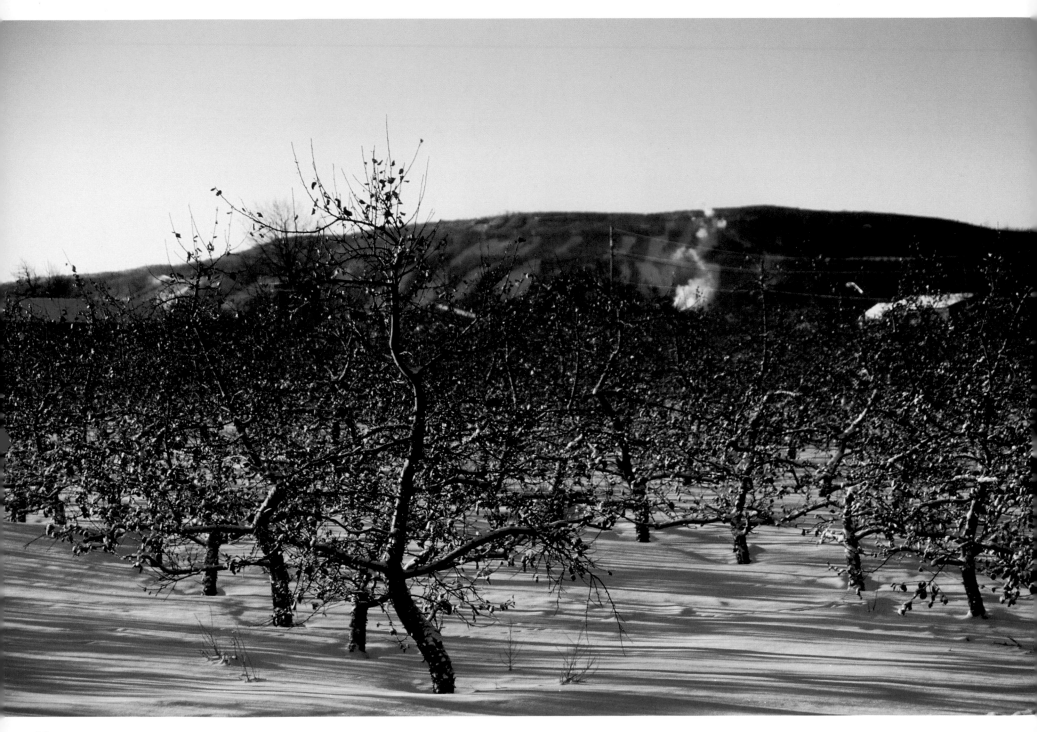

Apple Prizes

SOMETIME IN THE EARLY 1900s, an ambitious young farmer named William L. "Billie" Hamilton began to grow apples on his farm in Nottawasaga (now Clearview) Township. The fertile land of his 2-acre apple orchard was proving fruitful, so he increased it to 40 acres and concentrated on growing McIntoshes and Northern Spies, both important varieties at the time. His orchards thrived, and by 1912 his apples had won first prize at the Canadian Sweepstakes at the Horticultural Exhibit in Toronto (the precursor to the Royal Agricultural Winter Fair).

For years thereafter, Hamilton won trophy after trophy, everywhere from New York to London, England. His apple prizes became so legendary that he made headlines in the Toronto *Globe and Mail* on February 17, 1947, when he was hailed as the "apple king of the world."

From these illustrious beginnings, apples are still thriving, and winning prizes, in this southern part of Georgian Bay. More than 7,500 acres of orchards can be found in the district, stretching south from Thornbury and Clarksburg through the Beaver Valley and in fields around Meaford and Collingwood. In the springtime the countryside becomes as pretty as a pastel patchwork quilt, with white and pink orchards interspersed with newly green farmland. And everywhere the air is sweet with the scent of blossoms.

The potential for fruit farming here was discovered as early as 1835, when James Carson from Mono Township canoed up to Nottawasaga Bay looking for land. The area had been surveyed by then and plots made available for settlers. After paddling along the

OPPOSITE:
A snow-coated apple orchard with ski hills in the distance.

shore, Carson wrote in his diary, "… level land for farming, which with its shore front and sheltered by the hills behind, would be safe from late and early frosts, and would be an ideal spot for fruit growing."

Carson's predictions were accurate. Over the next few years, apple trees were planted all across the flat, fertile crescent of land tucked between the Niagara Escarpment cliffs and the blue-green waters of the bay. It turned out to be ideal soil for fruit growing too, with its combination of sandy loam and the silty clay left by the glaciers. The valley on either side of the Beaver River provided protection from the most severe weather. And the combination of the Escarpment and the cold water of Georgian Bay forms a microclimate that delays bud development in spring (lessening the chance of frost damage) and allows for a longer growing season in the fall.

In the early days, apples were packed into 4-foot wooden barrels and loaded onto steamboats in Thornbury Harbour for transport to northern Georgian Bay ports. Today the apple region (the most northern in Ontario) produces about 3 million bushels of McIntosh, Northern Spy, Red Delicious,

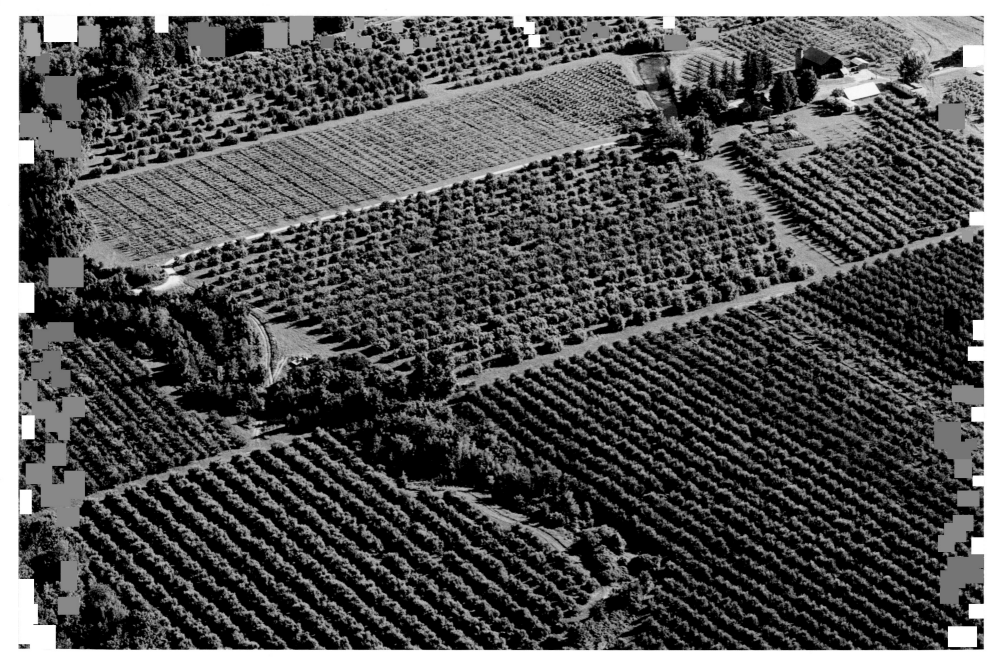

Apple orchards spread across acres of land in Grey County.

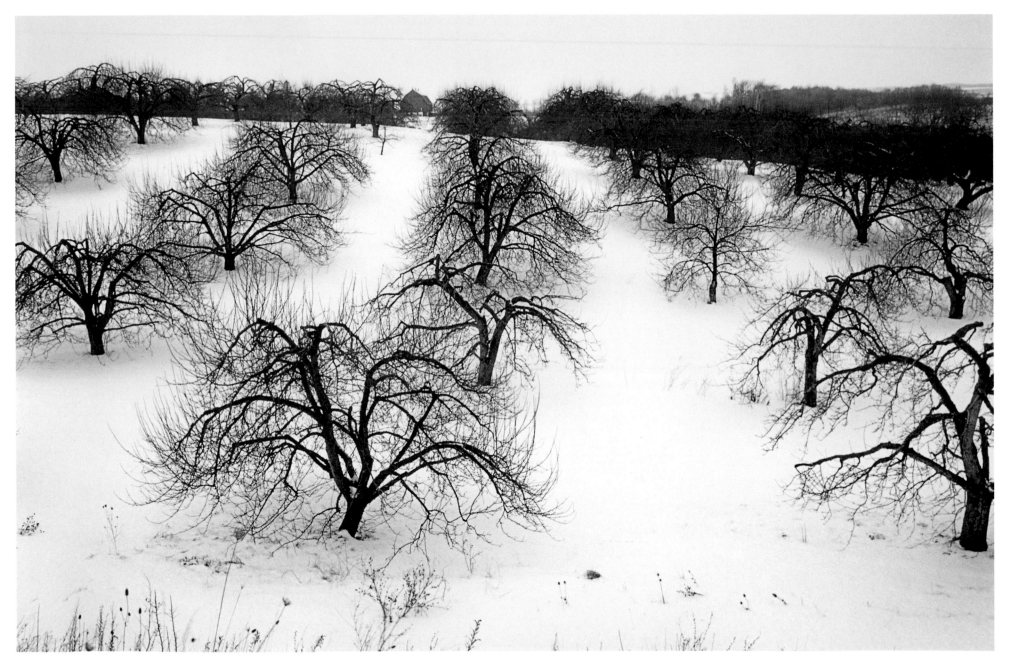

In winter the apple trees appear to be dancing across the snowy fields.

Empire, Spartan, Cortland and Golden Delicious. What isn't sold at farmstands is transported in air-ride temperature-controlled trailers to the United States and other destinations.

Much has changed for apple growers since the early days. Like other farming ventures, it isn't easy — cheap imports are threatening the industry, and the land is becoming more valuable than the crops. It's not unusual to see real estate signs planted among the burnt-out stumps of apple trees. But many orchards survive, and encouraged by new varieties like Honey Crisp that thrive in our area, apple farmers continue Billie Hamilton's legacy by winning prizes at county fairs.

However, back in the late 1940s, Hamilton's prize-winning days at the Royal Winter Fair in Toronto were numbered. Not long after he was dubbed "apple king of the world," he was barred from entering the sweepstakes. The officials in charge claimed that they wanted to give other apple-growing exhibitors a chance to win. And so the Apple King of Nottawasaga was unceremoniously deposed.

ABOVE: *Springtime blossoms sweeten the air at a vintage farm.*

OPPOSITE: *Winter feeding at Bluewood Stables in the shadow of the Blue Mountains.*

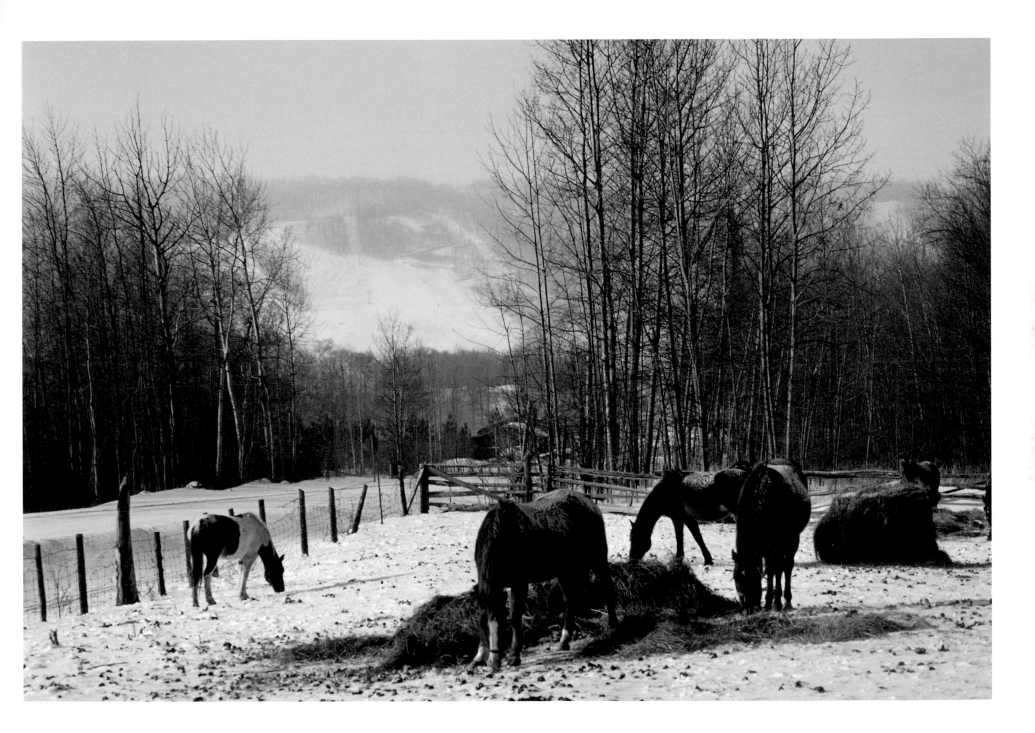

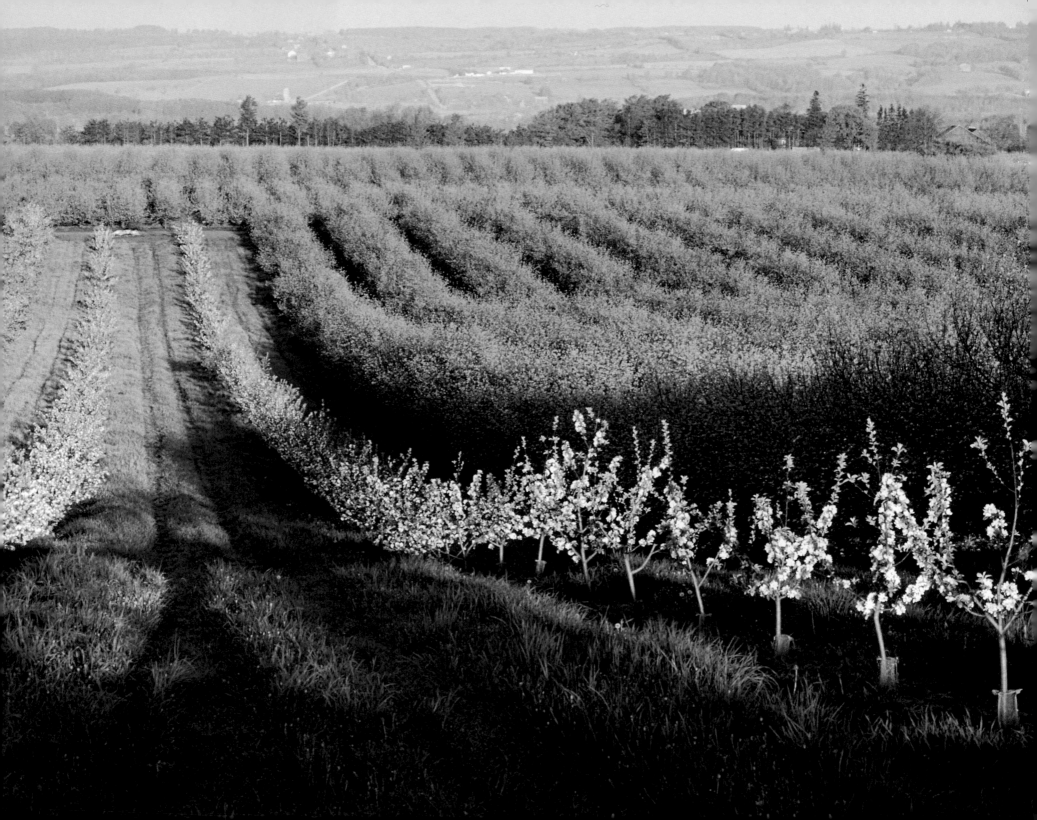

Even if I knew that tomorrow

the world would go to pieces,

I would still plant my apple tree.

MARTIN LUTHER

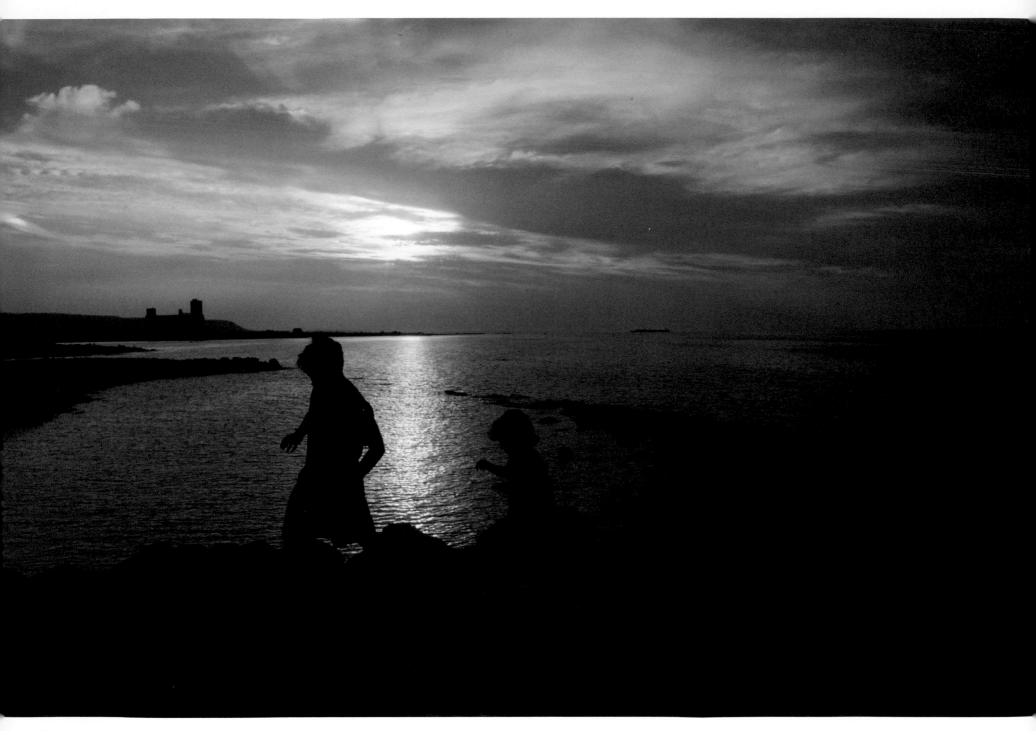

Shipbuilding Legacy

MAY **24, 1883.** Queen Victoria has been on the throne of England for 46 years, and today is her 64th birthday. Across the ocean in the little town of Collingwood, 5,000 people have gathered at the waterfront not just to celebrate the Queen's birthday but also to witness the opening of a new dry dock, which they named, in her honour, the Queen's Dry Dock. This facility would bring in ship-repair business and enhance the town's position as a significant harbour.

In the late 1800s, water transportation was the best way to move cargo and people. Schooners, tugs, barges and wooden steamers were all chugging about the Great Lakes, and the townsfolk of Collingwood were competing with other Georgian Bay communities, all hoping to become established as the gateway to the north and the west. At the time this was the best chance of prosperity for a budding harbour town.

Sidewheel steamboats were already making the journey from Collingwood into Lake Michigan and the ports of Chicago and Green Bay. These boats, impressively large, between 200 and 300 feet long, had mahogany-trimmed saloons and enough staterooms for 300 passengers. The Northern Railway had chartered them to provide a connection with their new train service — the Ontario, Simcoe & Huron Railway — which had reached Collingwood in 1855. Immigrants from Europe, en route to settle in the American West, filled the train cars with their household goods and then transferred to steamers for the journey to points west of Lake Michigan.

In the spring of 1883, the town folk of Collingwood were still recovering from a devastating

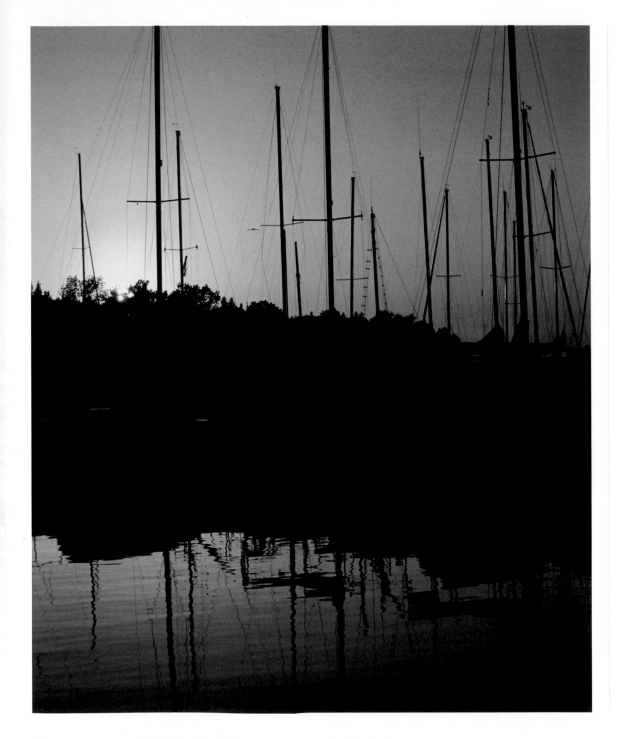

maritime loss that had occurred the previous fall. The *Asia*, a 136-foot wooden steamer, had pulled out of Collingwood Harbour on September 13, 1882, loaded with loggers, teams of horses and provisions for the north shore lumber camps. But because she had been built originally to ply the placid Welland Canal, not the temperamental waters of Georgian Bay, she was doomed. After crossing the northern part of the bay, she met up with a ferocious southeast gale, became battered and sank before reaching the lumber centre on the French River. Only two teenagers out of more than 100 passengers survived.

As well as mourning the loss of the *Asia*, the people of Collingwood were crushed by the news that the Canadian Pacific Railway, one of the town's main employers, had settled on their rival, Owen Sound, as the terminus for its steamship route into Lake Superior. It was a decision made by Henry Beatty, the railway's new manager of marine operations. He convinced the board of governors to run the railway line

Sailing at the Thornbury harbour,
a popular pastime with a long history.

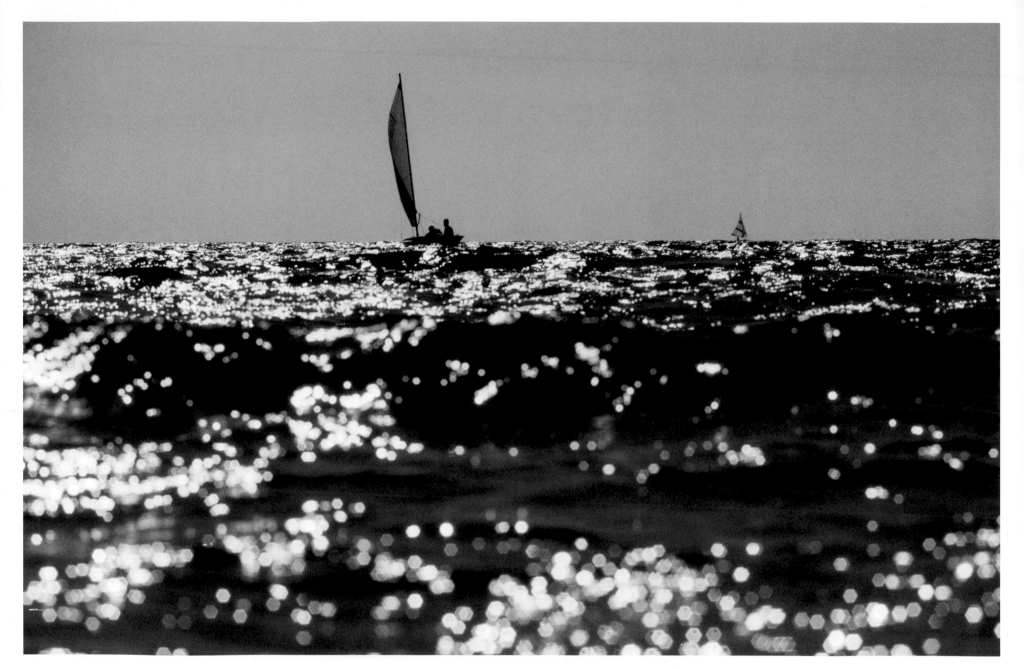

At Wasaga Beach, sailboats catch the wind on a breezy summer day.

into Owen Sound and make that port the base for their new steamship service. For the steamship company employees in Collingwood, this was a surprise — they knew that the harbour in Owen Sound was too shallow for these large ships.

So did the people in Owen Sound. Their only hope was to get their harbour dredged soon after the spring breakup. In a move worthy of James Bond, a baker from Owen Sound snuck into Collingwood on the train to attend a marine auction at the docks. He had been sent on this mission by a group of Owen Sound citizens who knew that their dredging needs could be found at this sale. The baker bought the lot — two dredges, every bit of dredging equipment, four scows and one tug. And as soon as the ice went out that spring, the Owen Sound harbour was dredged and deepened just in time to accommodate the big ships that were coming their way.

To make up for this loss, Collingwood needed a new business. The Queen's Dry Dock provided a platform for marine repair and was a step in that direction — a step that would initiate a long and lasting involvement with ships.

The Collingwood Terminals at sunset.

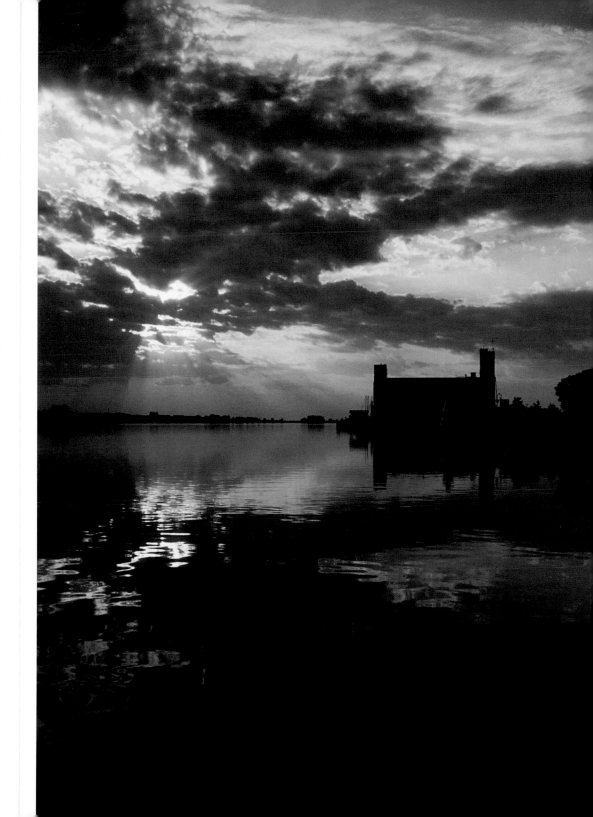

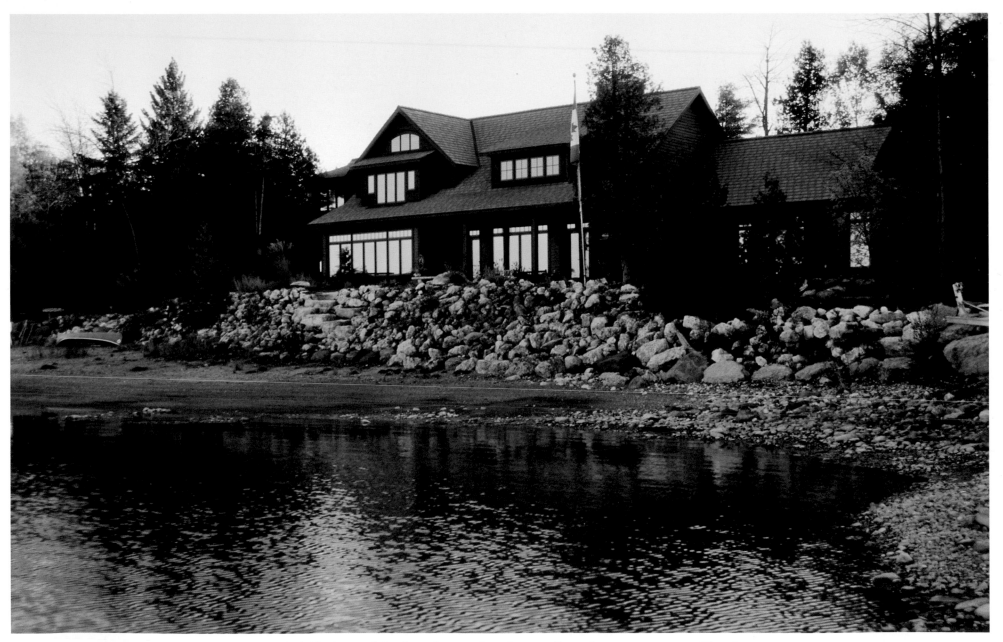

A newly built Arts and Crafts style waterfront home reflects the setting sun near Thornbury.
Boulders protect against the possibility of rising water levels.

Summer on the Water

5

SUMMER'S NEW BREEZES float across the still cold waters of the bay. From the cedar deck, the view is peaceful. Through a veil of mist, a lone sailboard flashes by, the odd seagull cries out in passing. The house is being readied for summer. Windows are flung open, pillows fluffed, slipcovers hung outside to air. Everything smells of old wood and warming earth.

Somewhere, for many of us, is a childhood memory of summer on the water. Perhaps a week spent in a housekeeping cabin by the sea or lazing about at a lakeside cottage. The very fact of being on the water suggests freedom — running barefoot on the beach, diving off docks into cool deep water, racing in and out of the cottage through screen doors that bang shut behind us. Beach picnics and bonfires, nights spent watching the stars — these are the things that draw us, as adults, to houses built on water.

A drive along Highway 26 from Wasaga Beach to Meaford offers glimpses of such houses. Some are well hidden, screened by clumps of trees, tucked at the end of country lanes that lead to the bay. Many are grand

The endless horizon on Georgian Bay, a body of water so large it is sometimes referred to as the 'sixth great lake'.

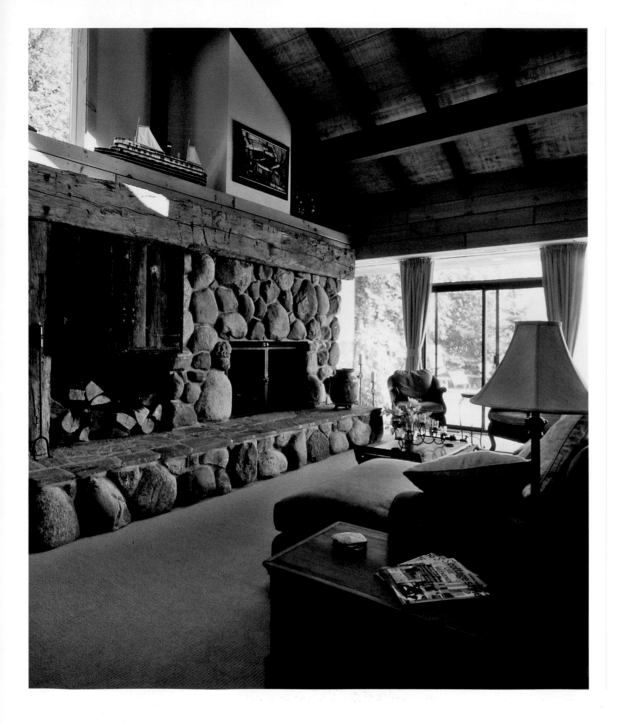

stone and beam mansions, lived in year-round and architect designed with expanses of glass to maximize the view. But in years past, most of the waterfront was lined with modest wooden cottages built strictly for summer use.

This is a story typical of one of those small cottages and how it grew.

Forty years ago, a couple, still in their twenties and living in Toronto, found a cottage on the water between Collingwood and Thornbury. It was a cared-for, but tiny, widow's house, and they bought it with friends because neither couple could really afford such a luxury. Over the years as their families grew — three daughters in one, two in the other — they shared the cottage every summer, the kids bunked in together in one big room separated from the main cottage and warmed by a space heater.

A stone fireplace dominates the living room and echoes the boulder-strewn beach outside. The mantel beam was found in a farmer's field. A corner window at the end of the fireplace captures a sunset view.

Now, as houses do, it has evolved. One family now owns it and over the years has made many changes and additions to the original building. It grew as needs dictated and has a higgledy-piggledy charm, with one room leading to another in unconventional fashion. Family collections of art, handmade log cabin quilts and antique doors fill the lively interior — and a totem pole stands guard over the living room.

Although now used year-round, in summer the house is at its best, with outdoor spaces that seem organic, as if part of nature. Trees grow up through weathered cedar decks, tall grasses flourish, wildflowers sweeten the air. Seating areas are positioned to face the water. And a boulder-lined pathway leads to the beach, which now, with low water levels in the bay, seems to stretch forever before the water begins.

ABOVE RIGHT: *A triptych of local scenery (from the Loft Gallery in Clarksburg) occupies a prime spot in the dining area of the great room. The totem pole, on the far right, is centred on a wall of glass overlooking the water.*

BELOW RIGHT: *Walls of windows flood the room with light and provide panoramic views.*

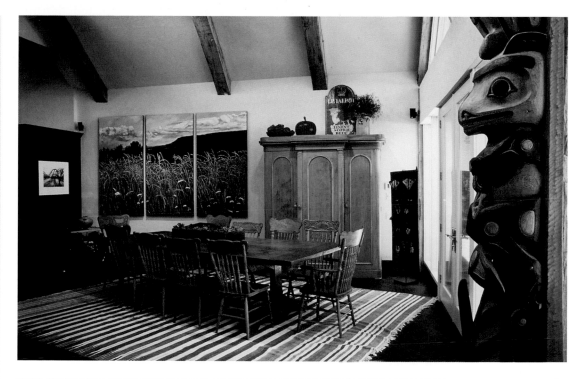

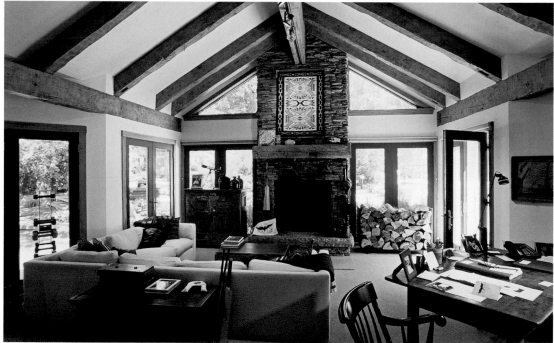

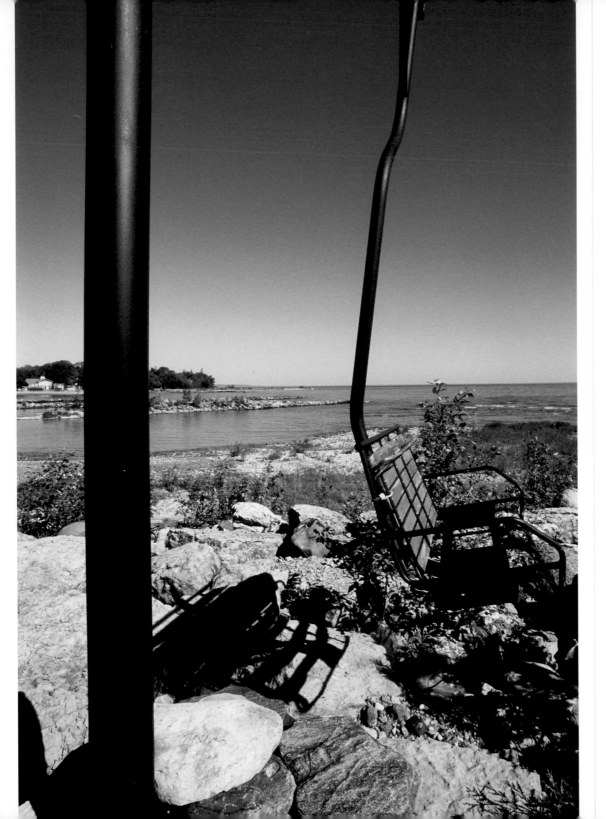

Summer is still lived outside, but the style is less rustic than in the days of old. There's a fancy outdoor kitchen beside the pool, with stainless steel appliances and a large teak dining area, all enclosed by screens. On warm bug-free nights, the family gathers around an outdoor stone barbecue large enough to grill burgers for a crowd. There's a tennis court and a playground for the grand-children. But despite all these new attractions, the most important legacy is ensuring that a new generation will be running free, digging their bare toes into the sand, and learning to love summer on the water.

LEFT: *A discarded chairlift relocated from the ski hill to the shore of Georgian Bay.*

OPPOSITE: *A view of the bay on a quiet summer afternoon from the stone terrace of a waterfront home.*

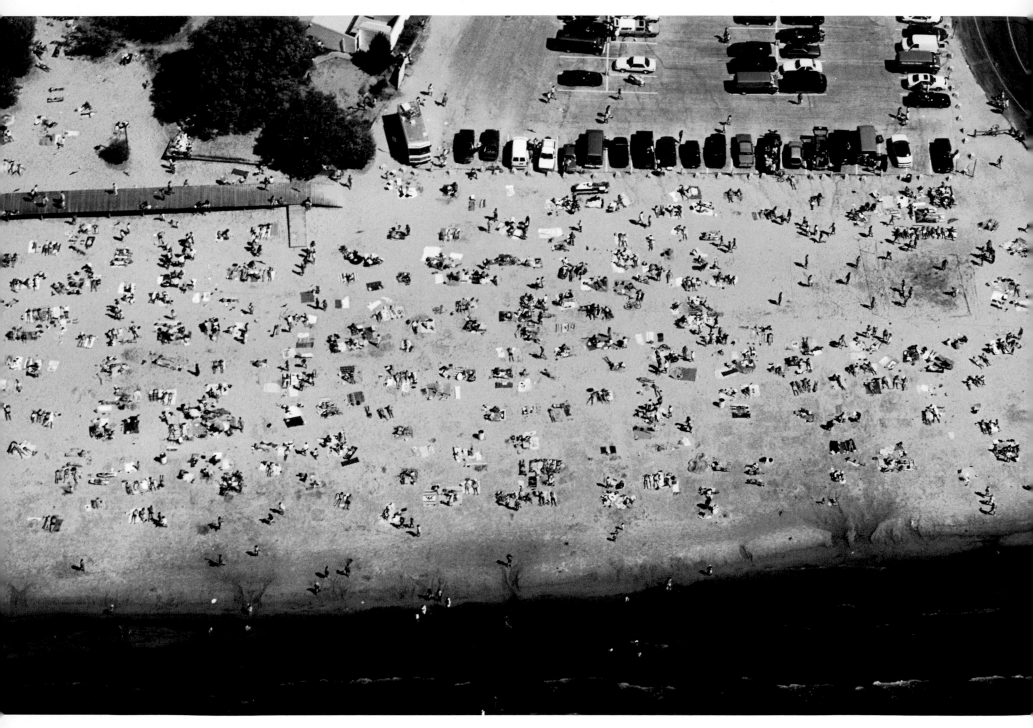

Wasaga Beach, the world's longest freshwater beach, fills with sunbathers and sandcastle builders every summer.

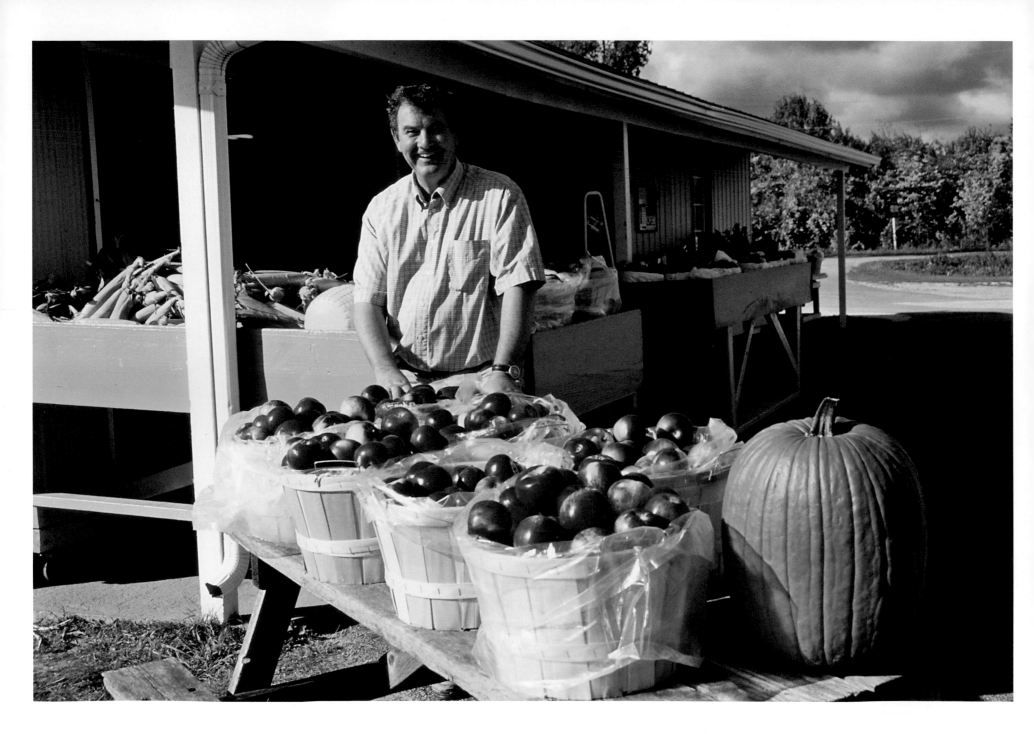

A VIEW OF THE BAY — COLLINGWOOD AND BEYOND

Currie's Market

THE FIRST CUSTOMER of the day is just getting out of his car as Alvin Currie heaps corn cobs, still coated with dew, onto a large wooden stand. "Another beautiful morning," he says, with an engaging smile. Every morning at nine o'clock from mid-July till Thanksgiving weekend, Currie's vegetable stand is open for business, and over that time they sell dozens and dozens of cobs of sweet corn (Currie's most famous product), as well as potatoes, raspberries, pumpkins, cantaloupes, beans, peas, cucumbers and peppers — anything that grows in the fertile fields out behind their stand.

In a world of big box stores and megamalls, Currie's is a testament to an earlier time. The simple structure, clad in siding with a tin-roof overhang shading the apple bins and a Canadian flag mounted on one side, has occupied the same corner at Sixth Street and 10th Line for over 40 years. And the Currie name has been connected to farming here for decades longer than that.

Even though what was once a crop field across the road is now a sprawling new subdivision and down at the next corner there's a new superstore, Alvin and his brother Neil keep farming the 150 acres that have been in their family since the 1930s. They start the tomatoes in greenhouses in the spring and plant corn seed in the fields. Then they transplant the tomato plants and put in the potatoes. By mid-July they'll open up the garage doors of their stand and have raspberries and new potatoes, the first offerings of the season, laid out and ready to sell.

All but 30 acres of their land is given over to cash crops like cattle corn, soybean, wheat and hay — the

OPPOSITE:
Alvin Currie, ready for business at his farm market stand.

rest provides fresh produce, some of which Alvin is now arranging inside on wooden tables. Everything under their roof comes from either the fields belonging to the Curries or from a farm or orchard nearby.

Farming has a rich history here, and Clearview Township, just south of Collingwood, boasts the largest number of farms of any Ontario township. It is still common to get stuck in the dust behind a slow-moving tractor putting along a back road, and come spring, the pungent whiff of manure is in the air. But the sad truth is that the family farm is worth more in development than in crops. Farmers like Alvin Currie think that some day all our produce will come from as far away as South America.

Records show that beans, corn and squash (the three sisters) were grown here by Aboriginals as early as the fourteenth century. But the major push into farming took place in the mid-1800s when immigrants from England, Scotland and Ireland came armed with

LEFT AND OPPOSITE:
A collection of old buildings and vintage farm equipment at Bygone Days Heritage Village, west of Collingwood.

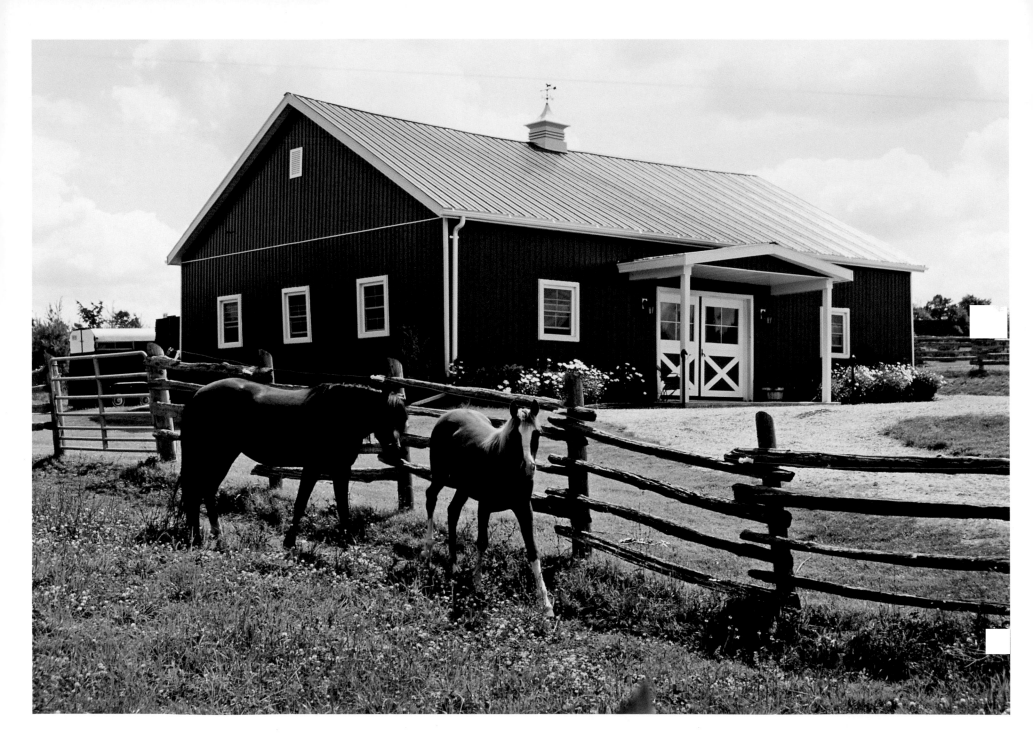

government land grants. The land they claimed proved to be fertile, and these pioneers produced turnips, potatoes, oats, spring wheat and peas. By 1846 the first apple orchards were planted, and by 1930 Georgian Bay apples were famous throughout North America.

The Curries' ancestors came from the island of Islay, off the coast of Scotland, and for a few generations, they were able to make a living in farming. But now, according to Alvin Currie, it's almost impossible. He's an electrician and his brother is a land surveyor, and "if we didn't have trades," he says, "we couldn't keep this up." Farming has never been easy, but when Smarts Brothers Ltd., the canning factory in Collingwood, closed down in 1966, it became tougher. "Everyone used to grow something to take to the canning factory," Alvin remembers. "And it brought in a little extra money."

As for the next generation, Alvin is skeptical. His two sons and his brother's daughter all have good jobs. They help out on the farm, but he can't see any of them taking it on. "They've seen how many hours it takes," he says. "It's all-consuming in the summer — you can't even take off to go fishing!"

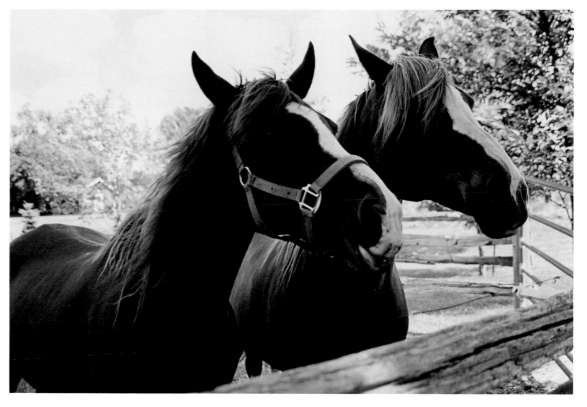

On the other hand, Alvin, who is now 60, can't think of anything he'd rather do. He's been here all his life — starting out selling tomatoes on this very corner when the road was unpaved and he was a gangly 12-year-old. "It keeps me healthy," he says as he picks out a dozen sweet corn for his customer. "And the developers just don't understand it. They think it's all about money. But I'm just not ready to walk away from it. Not yet."

ABOVE AND OPPOSITE: *At Windy Hill Farm, near Duntroon, much of the property has been given over to horse paddocks and a large riding ring. Inside the restored circa 1890 livery barn is a pristine tack room.*

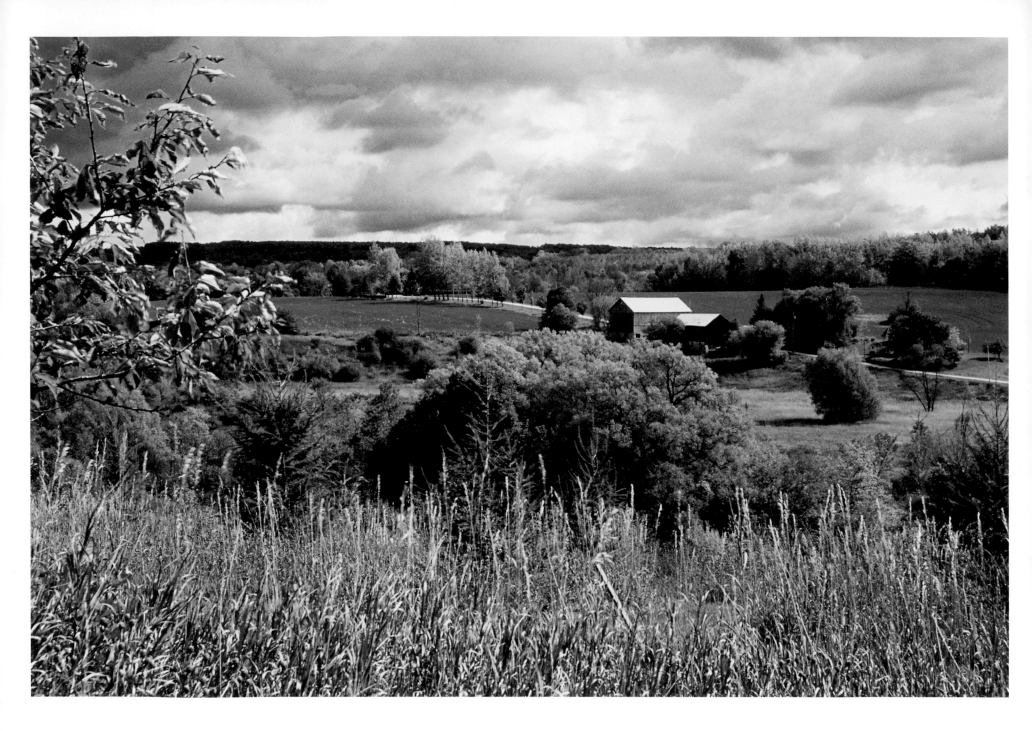

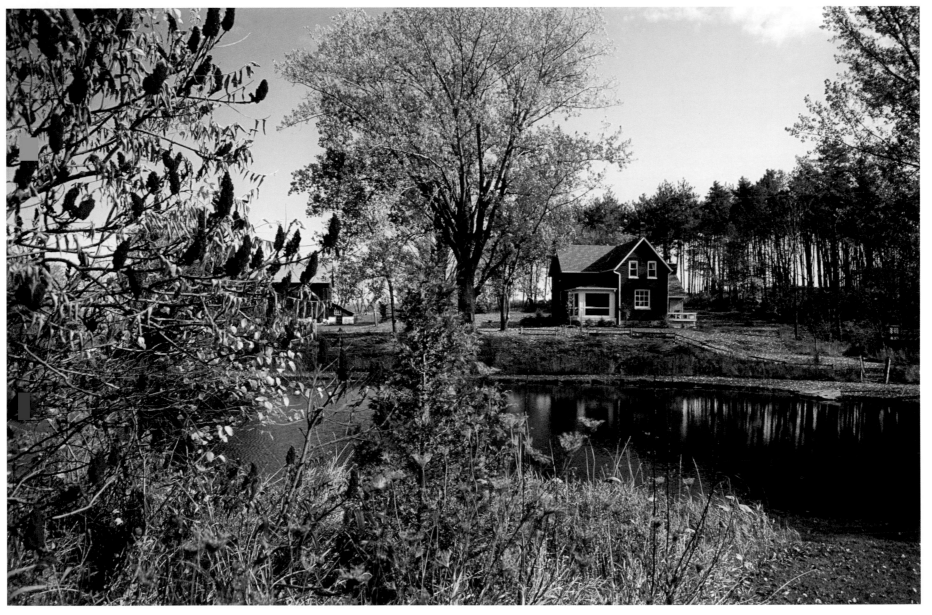

ABOVE: *The pond, barn and century farmhouse at Sweetwater Farm, north of Creemore.*

OPPOSITE: *A pastoral scene in the Beaver Valley.*

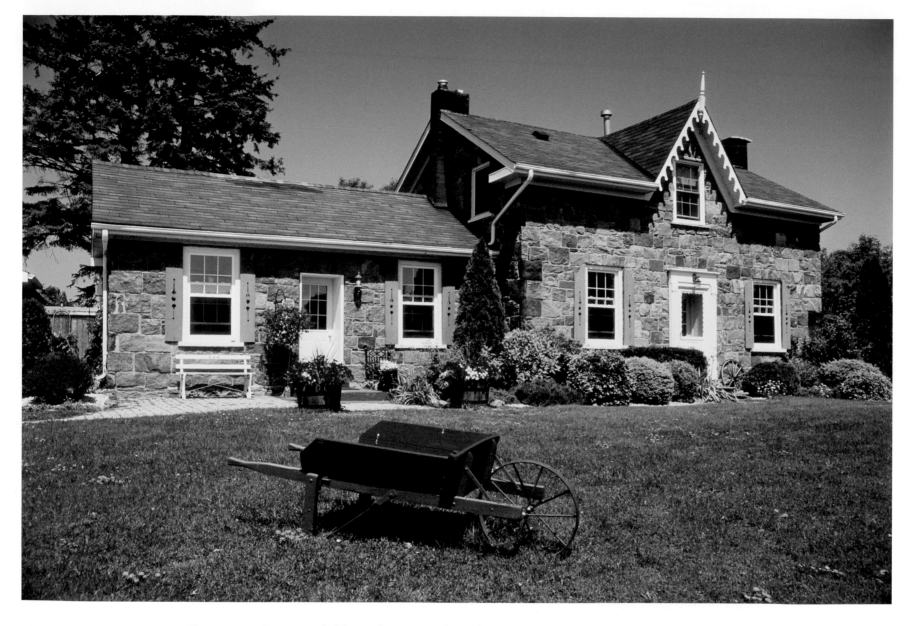

ABOVE: *This nineteenth-century fieldstone home east of Meaford was once surrounded by acres of apple orchards.*

OPPOSITE: *Cedar split-rail fences line the laneway at Wellspring Farm, a 50-acre property near Honeywood.*

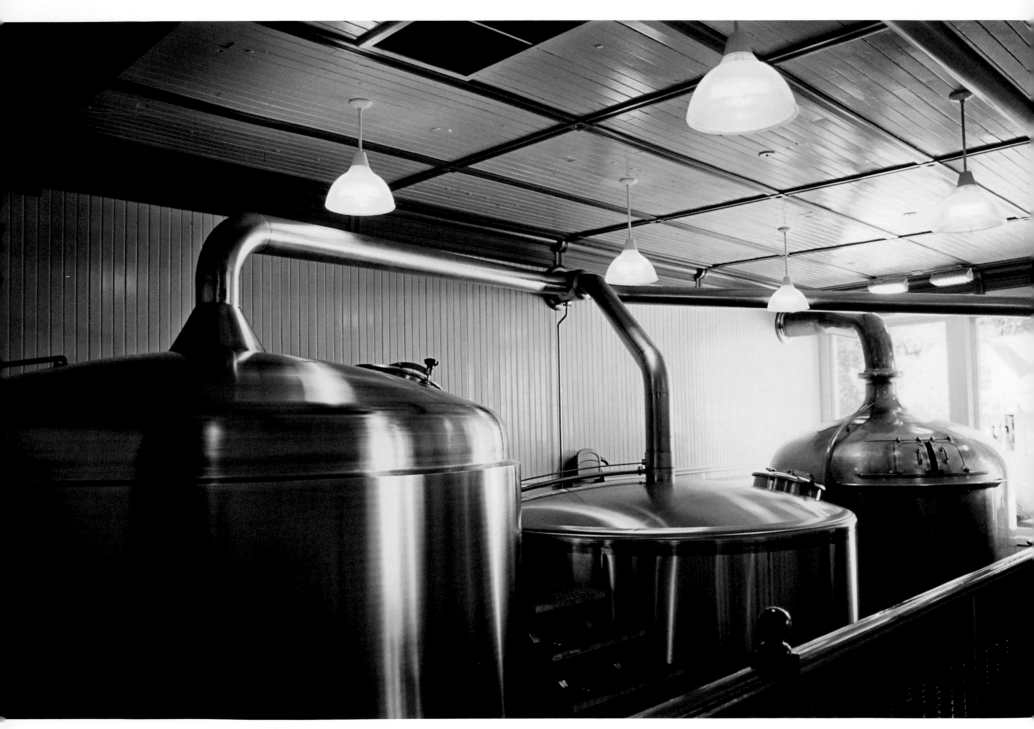

Creemore Springs Brewery

UGUST **15, 1987.** The day is sunny and cloudless, and the village of Creemore has never looked lovelier. The canopy of sugar maples shading the gracious brick homes at the north end of Mill Street is in full leaf, and at the south end, a celebration is taking place. The town folk are out in force to witness the opening of a new brewery, located in an 1894 building that was once the May Hardware store. The sweet, musky scent of malted barley and hops wafts through the vintage doors onto the street. The Fig Leaf Jazz Band is belting out Dixieland tunes from on top of a hay wagon parked in front of the new brewery. A parade marches up the main street, and everyone over 19 is invited to the arena for free tastings. Before the day is over, 2,000 glasses of Premium Lager will be downed.

Opening Creemore Springs Brewery in the tiny village was the brainchild of marketing executive John Wiggins and four others, including Curtis Zeng, who was head brewer back in 1987. "We had fourteen hundred 750 ml bottles of lager for sale that day," remembers Zeng, who is now vice president of operations. "We thought that would last the day, but we sold out in under an hour. That was a very good beginning."

The brewery today operates in the same way it always has — proud to be, as they claim, "a hundred years behind the times." The beer originates on a farm just outside of town where pristine water flows from a spring. It is this clear spring water that is the secret ingredient. The brewery transports the water in a converted milk truck and stores it in refrigerated stainless steel tanks. The method of brewing may be ages old, but the equipment is thoroughly up to date.

OPPOSITE:

The gleaming interior of the Creemore Springs Brewery.

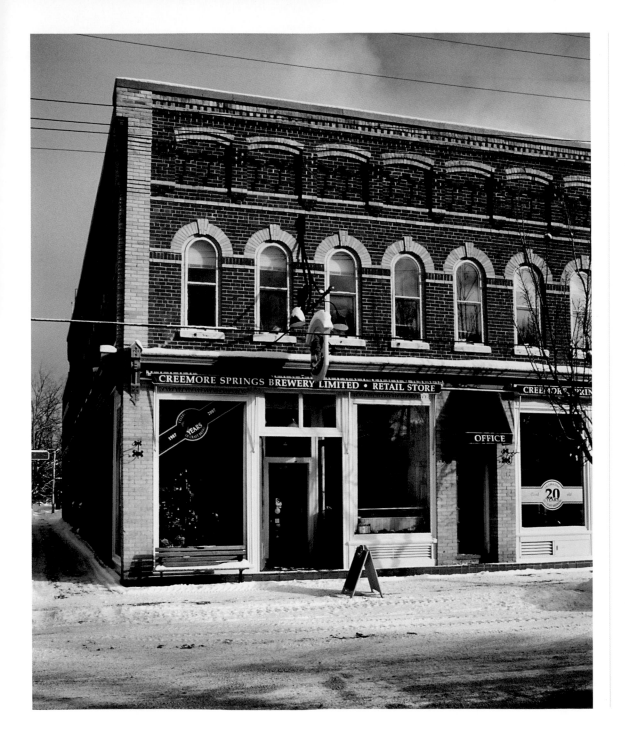

From the storefront window, passersby can see the brewing kettle and fermenting tanks. Inside, they see the beautifully restored building with original wooden floors, Wedgwood blue crown moulding and tongue-and-groove walls. It's a step back in time. People come from all over to have a free tour and tasting and to pick up a six-pack of their favourite brew, as well as choosing a souvenir from the brewery's T-shirts, sweatshirts, beer mugs and baseball caps. They also come to experience a town that does seem to be a hundred years behind the times. Set in the valley where the Mad and Noisy rivers meet and surrounded by the Purple Hills, it's like a movie set for a pretty Ontario village. The name *Cree Mohr* means "big heart" in Gaelic, a reflection of the language of the original settlers, who came from Ireland and Scotland in the 1800s.

One of those early settlers, a Scot named Edward Webster, travelled to the area all the way from

Creemore Springs Brewery and Retail outlet was once the May Hardware store, built in 1894 on the village's main street.

Gananoque in eastern Ontario. His journey — he and his family in a sailboat in the 1840s — went something like this: Leave Gananoque and sail down the St. Lawrence to Lake Ontario. Enter the newly built Welland Canal and travel into Lakes Erie, St. Clair and Huron. Head north on Lake Huron, around the Bruce Peninsula and down into Georgian Bay. Sail up the Nottawasaga River as far as possible. Then transfer family and cargo to an ox cart and slash through almost impenetrable bush to reach the river valley where they would found the settlement that became Creemore. A year later he and others had built a sawmill and a flour mill on the Mad River. Things progressed so quickly from these rough beginnings that Webster had his land surveyed into town lots, named the streets for his sons and daughters and sold lots to new arrivals.

Today, the village maintains its old-fashioned ways despite development encroaching on its fringes. And the Creemore Brewery, although owned now by the global beer company Molson Coors, is still brewing its unique amber lager by direct fire, in small batches, using only four ingredients (malted barley,

A trompe l'oeil window painted on the outside wall of a Creemore store.

hops, water and yeast) and delivering it fresh weekly. And just like the town with its "big heart," the brewery still believes in putting tender loving care into its great beer and continuing to be "proudly a hundred years behind the times."

THIS PAGE: *The eclectic buildings of Creemore,
known as the "little village with a big heart."*

OPPOSITE: *Gothic tracery above the doorway at St. John's
United Church (erected in 1886) on Mill Street in Creemore.*

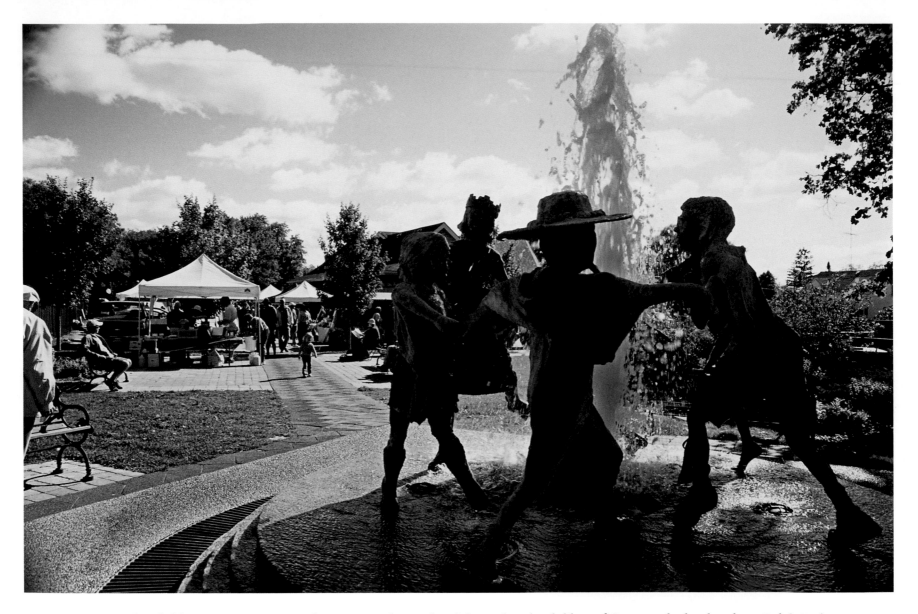

ABOVE: *The* Children's Dress-Up Dance *fountain was designed and donated to the children of Creemore by local sculptor Ralph Hicks.*

OPPOSITE: *The Nottawasaga River, a Native name meaning "river outlet of the Mohawks."*

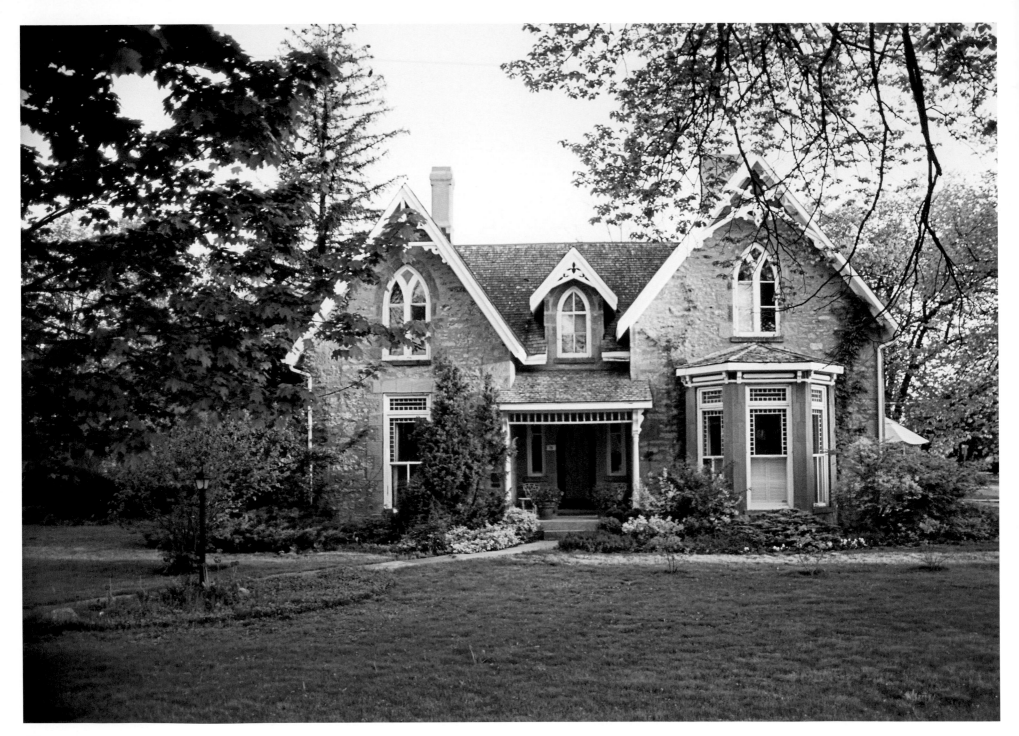

All Saints' Rectory

8

THE HANDSOME STONE HOUSE with its deep gables and pointed arch windows is a showstopper in Collingwood, one of the finest examples of Gothic revival architecture north of Toronto. It was built in 1878 as a home for the rector of All Saints' Anglican Church and well used as such for many years. By 2002, however, the four-bedroom house was vacant, the rector at that time living elsewhere, and church members decided to look for a suitable tenant.

Coincidentally, Arlene Noble had been visiting a friend in the area and thinking about where she would like to live. She noticed the ad in the local newspaper and went to see the house. "Of course I loved the exterior instantly," she recalls, "but inside it was a little sad. Nothing had been done to it for many years, but I could see the potential. I knew it would be a lot of work, but I like a challenge." It didn't take long for the church committee to come to an agreement with her. In return for paying for all the interior work (and tackling a good deal of it herself), she was given a 20-year lease at a set rate renewable every five years. And she agreed to open the house, on occasion, for church functions and charitable events.

The All Saints' rectory in Collingwood, a fine example of Gothic revival architecture.

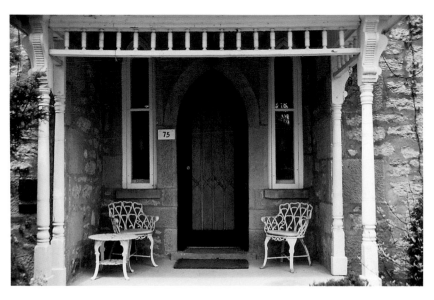

The work began in May 2002. Arlene researched the Gothic revival palette and chose paint colours that reflected that period — rich jewel tones that contrast elegantly with the ornate mouldings. She opted for paint rather than wallpaper in order to showcase the stately architecture. The windows are almost all original, and low to the floor so that views become part of every room. Some have arched tops that reveal their Gothic heritage; others have borders made from small squares of coloured glass, a different colour combination for every room. "The windows and the light were the first things that attracted me to this house," says Arlene. "I can move from room to room and follow the natural light all day. It's never gloomy. Builders back in those days really understood scale and light."

The impetus for building the grand house was, it seems, a case of "rectory envy." In 1877 when the Reverend Lawrence Kirby came to All Saints', his good friend the Reverend William Forster was in Creemore at St. Luke's Anglican Church. Forster had built a splendid rectory for himself just west of town. Built of board and batten, it was designed to look appropriately ecclesiastical, featuring the neo-Gothic embellishments so popular in England at that time. The handsome rectory known as Claverleigh became the centre of social life in Creemore.

ABOVE: *A small terrace at the side of the rectory captures the afternoon sun.*

OPPOSITE: *The rectory kitchen was updated with gallons of pea green paint.*

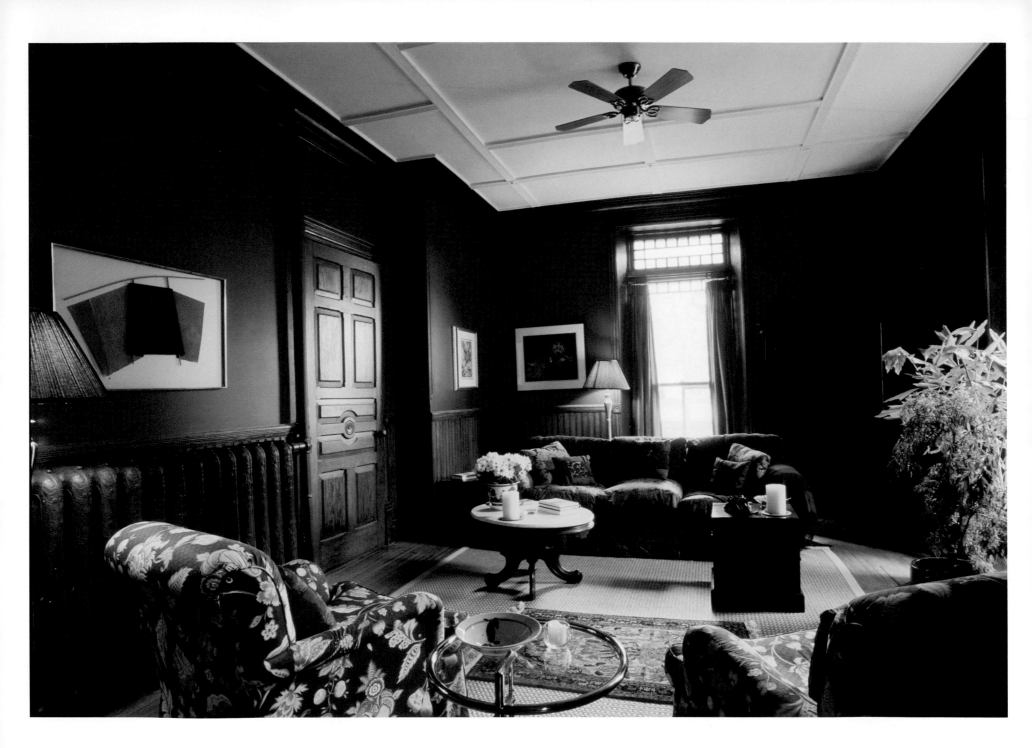

Meanwhile in Collingwood, Kirby decided that he should also live in a handsome rectory. He obtained the plans for Claverleigh and set out to have his own version built on land just south of the church. But his would be somewhat grander, made of fieldstone instead of wood. A local builder, Robert Burdett, was hired, and his contract proposal, dated October 28, 1877, is still in the church archives. It reads:

> … *Build the proposed Parsonage of stone, according to the plan of Mr. Forster house Creemore furnishing all Material for the same, that is Stone work Carpenter work painting and glazing for the sum of fifteen hundred and fifty dollars ($1550.00) Terms $1350 cash. Balance in one and two years with intrest of 8 pecet [sic]. This offer does not include verhanda [sic] nor front porch. Yours respectfully, R. Burdett*

Thus Kirby got a home and showpiece suitable to someone of his stature in the community. And although the eventual cost was a little over $2,200 and he had to pay some of it himself, he lived in his wonderful stone manse until 1900, when he was transferred to the Parish of Aurora. With the exception of the exterior material, Claverleigh and the All Saints' rectory are identical.

Claverleigh still exists, a few miles west of Creemore on a plot of land at the forks of the Noisy and Mad rivers. It is in private hands and hasn't been affiliated with the church for over a century. In Collingwood, however, the graciously restored rectory is once again serving the purpose it was originally built for — a home first, but also a gathering place for the local community.

OPPOSITE: *The red room with a high ceiling and ornate moulding was once the rector's study.*

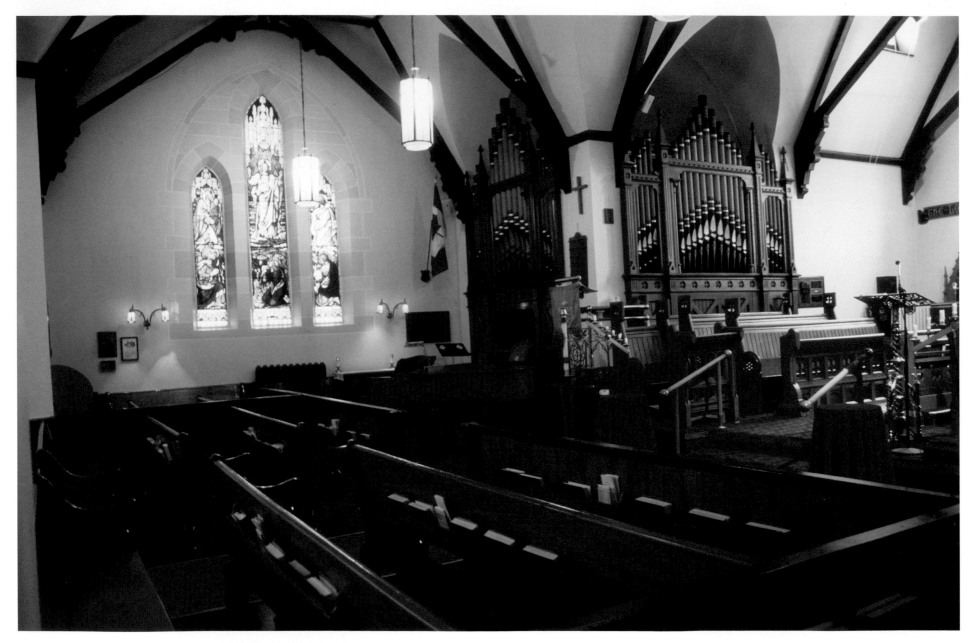

ABOVE AND OPPOSITE: *The interior and exterior of the beautiful All Saints' Anglican Church on Elgin Street in Collingwood. Erected in 1858, it was expanded in 1876 to include transepts, chancel, sanctuary and bell tower.*

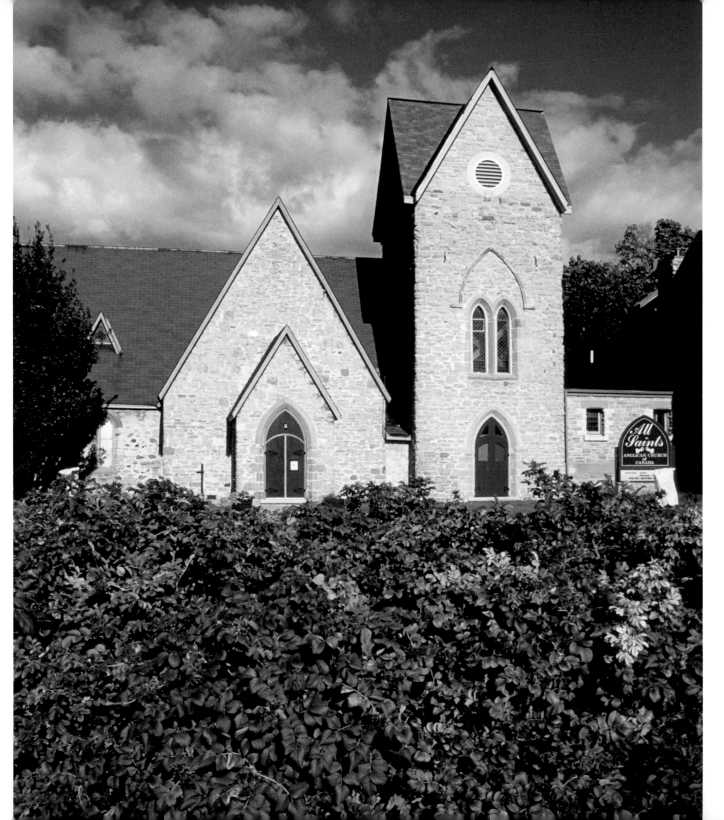

The Escarpment — Our Backbone

<div style="text-align: right;">9</div>

IT IS A SOFT SEPTEMBER DAY, the sun still warm and the crickets still murmuring as she hikes through old pasture land that edges a small stream valley. Following the blue and white blazes that have been painted on trees, she can hear other hikers up ahead on the Lorce Forest Loop, one of numerous trails that criss-cross the Niagara Escarpment. After navigating a shale-covered slope, she skirts through ancient white cedars clinging to the cliffs and comes to the top of the Escarpment at the Georgian Peaks ski club, her favourite place to stop and soak up the view. The air is clear and she can see all the way to Christian, Hope and Beckwith, three islands on the far horizon — and, in between, the dazzling deep blue of Nottawasaga Bay.

In this area, from Osler Bluff through the Rock at Scenic Caves to Georgian Peaks, the Niagara Escarpment is called the Blue Mountains and reaches its highest elevations — up to 510 metres (1,670 ft) above sea level. The entire ridge of limestone, which goes from Queenston on the Niagara River to Tobermory on Georgian Bay, is such a valued resource

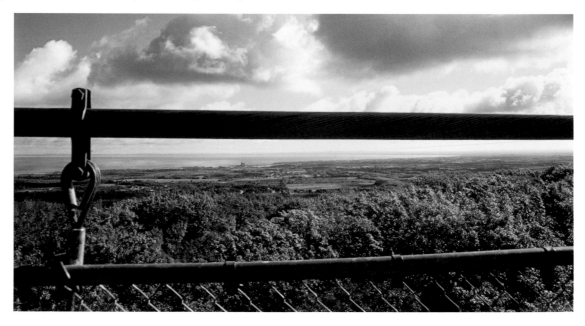

to all who live near it that its protection has become a crusade for environmental activists. When UNESCO, the United Nation's designating body, declared the Niagara Escarpment a World Biosphere Reserve in 1990, it meant that the Escarpment's unique natural features fell into the same category as the Serengeti National Park in Africa, the Florida Everglades and the Galapagos Islands. Although biosphere status identifies this ecosystem as "worthy of preservation for all time," it is still unprotected and needs advocates to keep it from those who are hankering to develop it — or to mine its riches.

There is a provincial watchdog: the Ontario Niagara Escarpment Plan, established in 1985 and the subject of ongoing debates over development and control. But still, the entire Escarpment might have remained just a geological curiosity — a ribbon of wilderness observed from a distance — if not for the vision of Ray Lowes, the man who inspired the creation of the Bruce Trail, a footpath that traverses it from end to end.

Hiking on the Bruce Trail,
Canada's longest and oldest marked footpath.

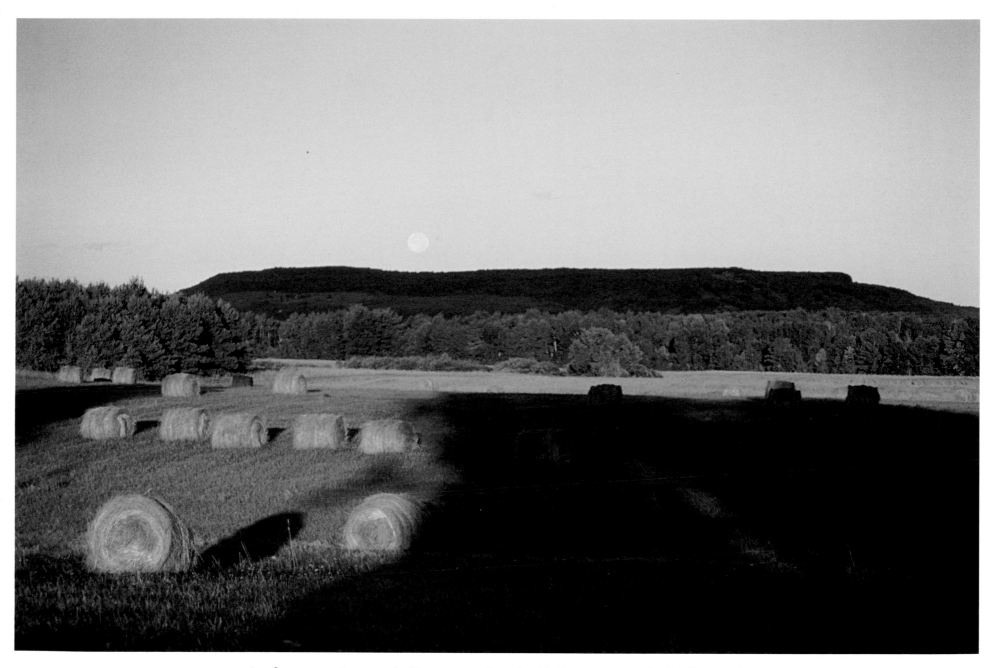

A pale moon setting over the Escarpment along the 6th Concession, south of Collingwood.

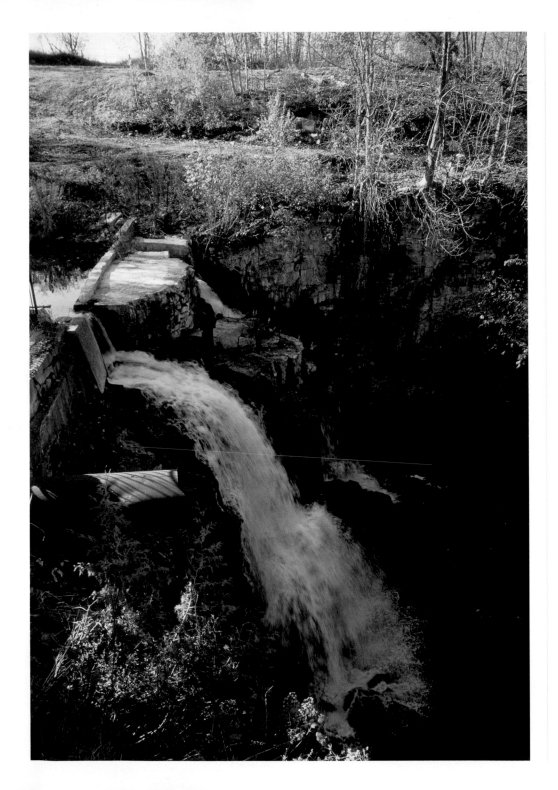

Lowes was part of a group of naturalists who proposed the idea of the Bruce Trail in 1960, and soon a groundswell occurred. Volunteers signed up to cut through the bush, build bridges and boardwalks and paint blazes (white for the main trail and blue for offshoots) on trees and fence posts. By 1967 — Canada's centennial — the trail was open. Part of the land is owned by the volunteer-run Bruce Trail Association, 47 percent is on Crown land and the remainder is private property whose owners have been generous in allowing public access.

On a map the Bruce Trail twists and winds, creating a jagged link between Queenston Heights and Tobermory. Its unbroken pathway stretches a total of 845 kilometres (525 mi), with a chunk of it wending its way through southern Georgian Bay. In this area it loops across cliffs and uplands and then dips its spiny fingers down into the Beaver and Pretty river valleys.

LEFT: *Walters Falls,*
one of seven waterfalls in Grey County.

OPPOSITE: *A bird's-eye view*
from the top of the Blue Mountains.

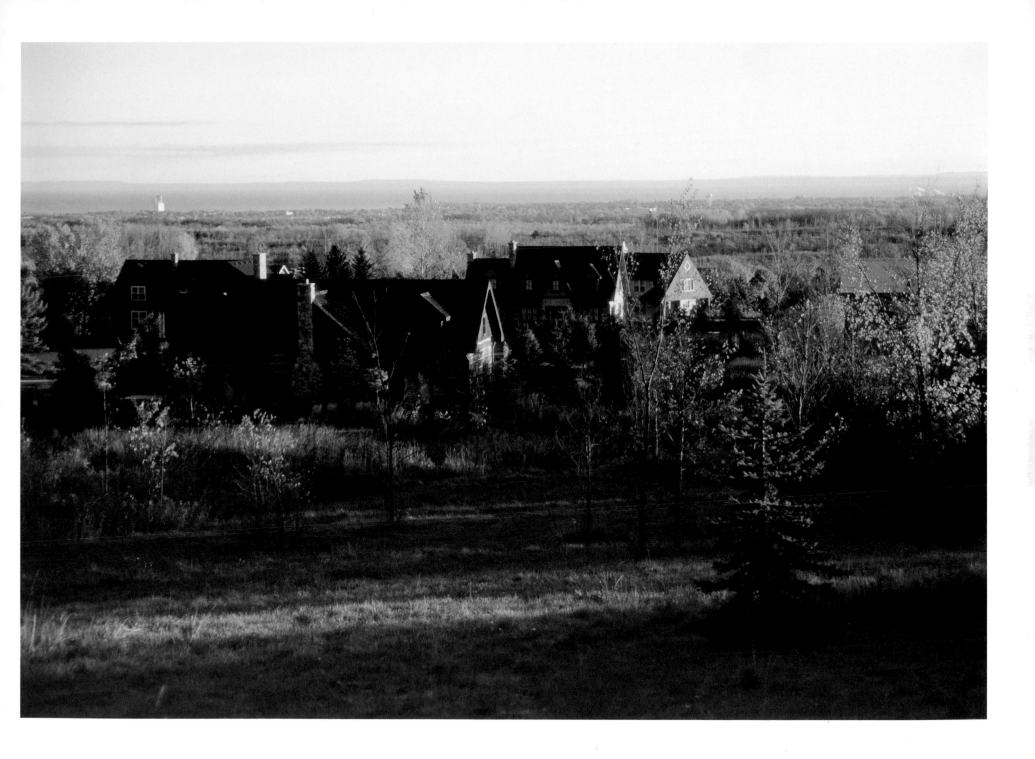

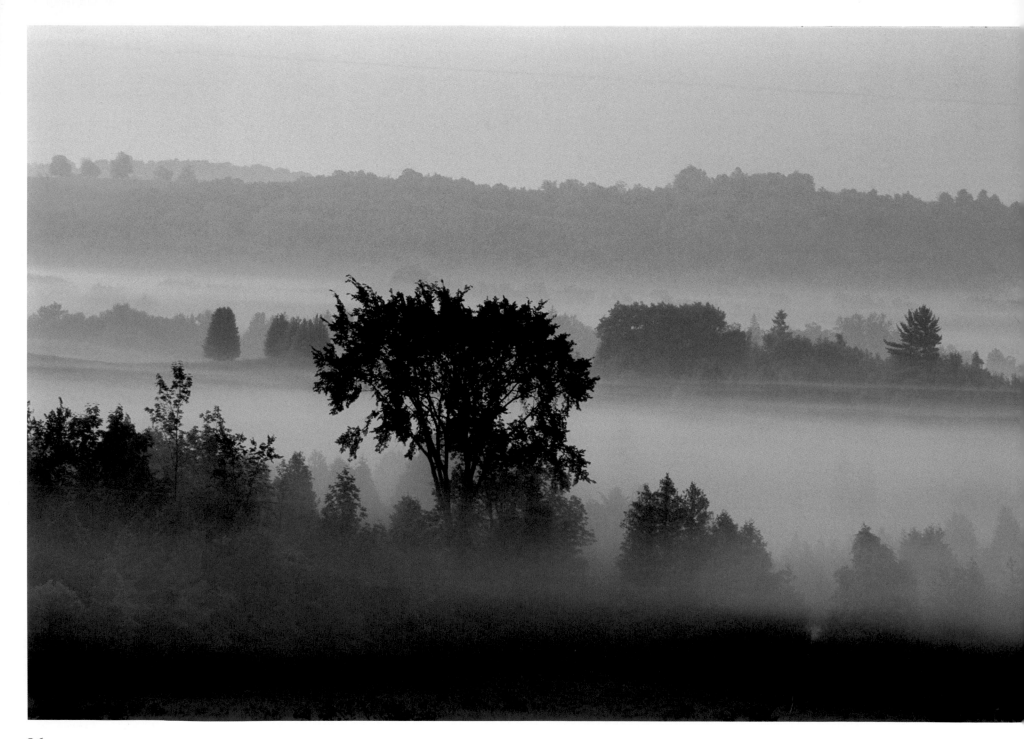

And across the trail's entire breadth, a great variety of wildlife has been discovered — 300 species of bird, 36 of reptile and amphibian, 90 kinds of fish, 53 mammal species and hundreds of rare varieties of plant, like hart's tongue fern.

But there is a dark side to this story. In places along the ridge, gigantic limestone quarries and gravel pits have left gaping holes in the otherwise pristine landscape. Certain sections of the Niagara Escarpment are designated "mineral resource extraction areas," where quarry operators are allowed to dig pits and extract the mineral aggregate resources that are required by Ontario's construction industry.

A deep concern for the future of the Niagara Escarpment propelled Sarah Harmer, an award-winning singer-songwriter, to hike the Escarpment in 2005, playing gigs with her bandmates and spreading the word by song.

If they blow a hole in the backbone,

The one that runs across the muscles of the land,

We might get a load of stone for the road,

But I don't know how much longer we can stand.

Sarah Harmer, "Escarpment Blues"

OPPOSITE: *Morning mist in the Pretty River Valley.*

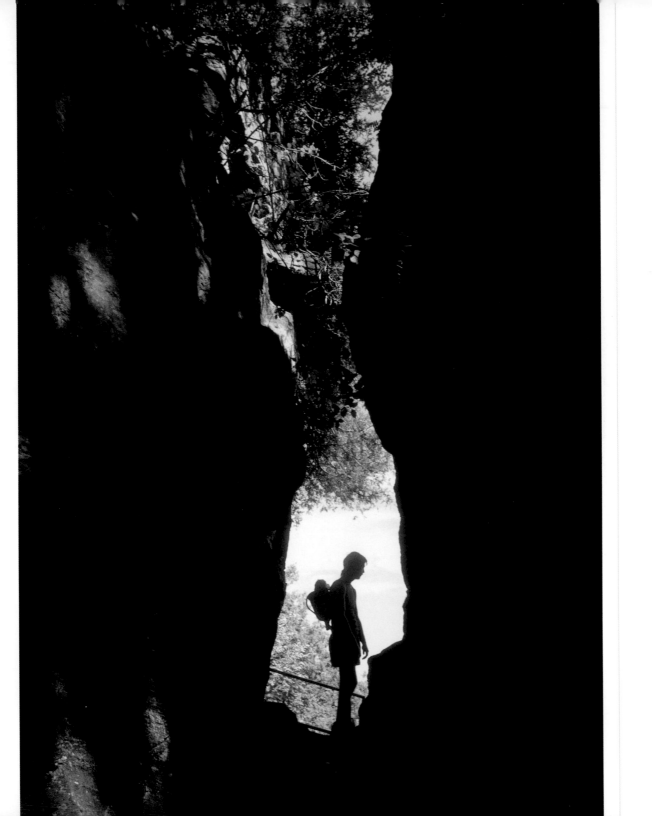

LEFT: *Exploring the deep rock crevices at Scenic Caves Nature Adventures on the top of the Blue Mountains.*

OPPOSITE: *Biking on the Georgian Trail, a former railway bed linking the towns of Collingwood, Thornbury and Meaford.*

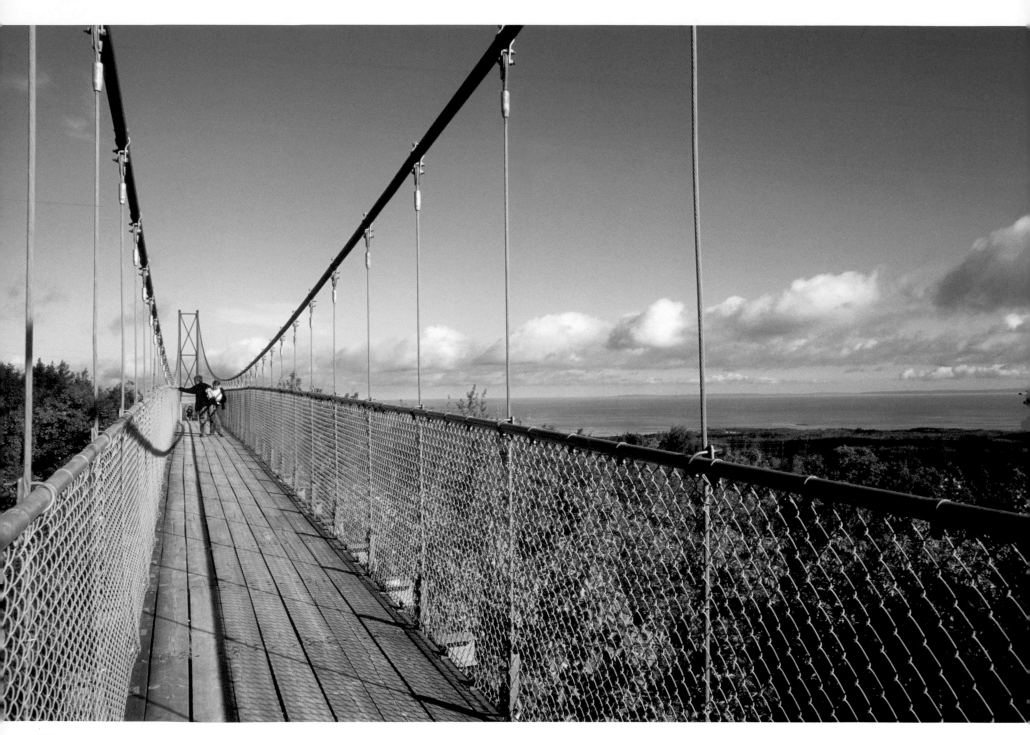

ABOVE: *Late fall at the Cranberry Resort's 18-hole, par 72 golf course.*

OPPOSITE: *The 126-metre-long (413 ft) suspension bridge at Scenic Caves soars more than 300 metres (984 ft) above Georgian Bay.*

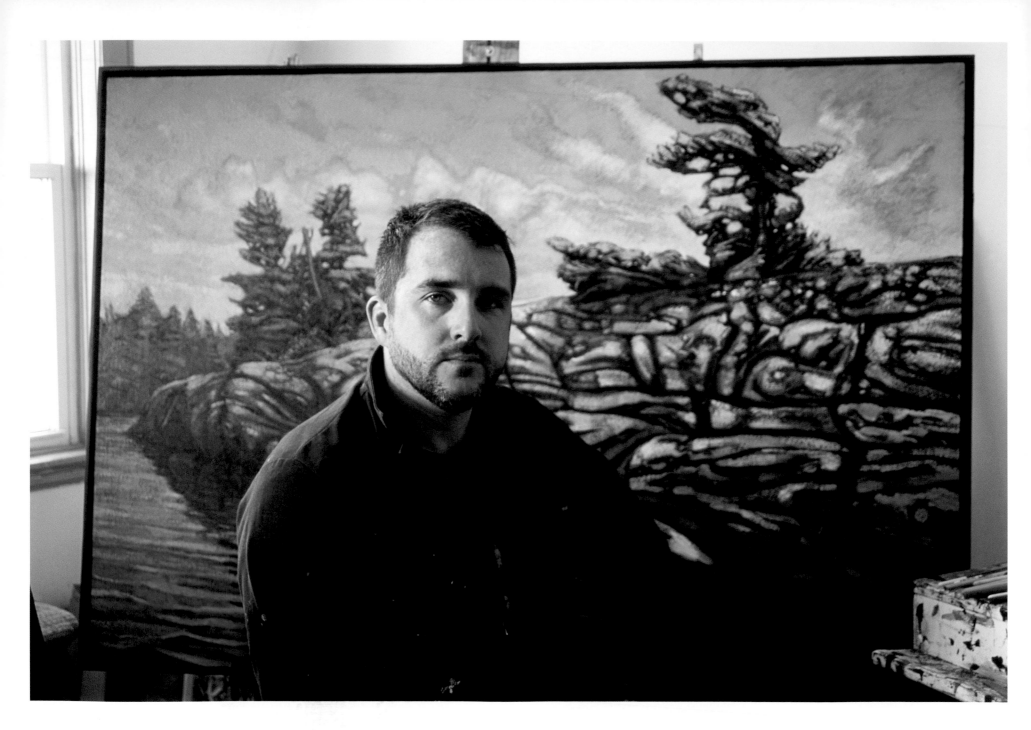

Artists Find Their Muse

A STEEP, DIMLY LIT STAIRCASE leads up to the Level Gallery, located above a store in downtown Collingwood. The art-filled space, however, is far from dim. It's bright and loftlike, awash in colour and light, the walls hung with landscapes painted mainly by local artists. The gallery's very existence is proof of the number of artists who have come to live in this region. There are painters, potters, sculptors, glass artists, metal workers and photographers — all discovering their muse in the ever-changing landscapes of southern Georgian Bay.

In 1988 the first artist studio tour was held. Sponsored by the Blue Mountain Foundation for the Arts, it began as a low-key affair but now, 20 years later, has blossomed into a major annual happening held the first weekend of June. Almost every community now mounts these popular tours, allowing artists to open their homes and studios to the public. From the Purple Hills to the Beaver Valley, these weekend events draw enormous crowds enticed by the idea of driving down hidden back roads to find an artist at work in an old barn or of discovering that a heritage schoolhouse is now a potter's studio.

Level Gallery is just one of many art showcases. It represents over 40 Canadian artists, although it began as an outlet for the work of the seven painters who call their collective Drawnonward. The term is a palindrome, meaning it reads the same from front to back or from back to front. Either way — it's a metaphor for an artistic journey.

The artists, all men in their thirties, have known each other since high school. Their journeys involve travelling together into the Canadian wilderness to

OPPOSITE: Artist Paul Mantrop in front of his painting White Pine, Georgian Bay *at the Level Gallery in Collingwood.*

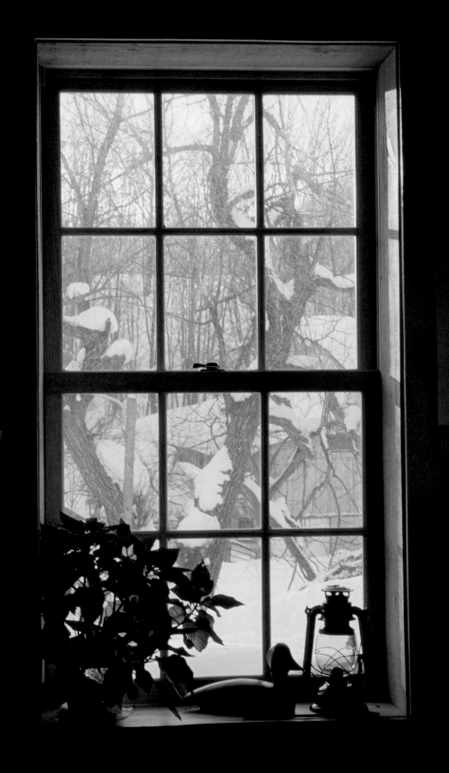

paint (much in the style of a former famous Group of Seven). One of them, Paul Mantrop, owns the Level Gallery. The others are Jeremy Down, David Marshak, Steve McDonald, Chris Roberts, Robert Saley and Gordon Kemp. They have congregated in this area thanks in large part to Gordon's father, one of Blue Mountain's most revered artists, the late Robert G. Kemp.

In 1961, Robert Kemp did what many artists dream of doing. He quit his day job in an advertising agency in Toronto and moved to Blue Mountain to paint full-time, taking up residence in a chalet at the base of the mountain. He became famous as he roamed the countryside and ventured down back roads, stopping to capture on canvas and paper the essence of the area and its people. His sensitive paintings and lyrical descriptions are assembled in *Robert G. Kemp's Paintings and Drawings of Rural Ontario*, a coffee-table book published in 1983.

LEFT: *Artist Bill Franks' dining room window at Troon Cottage on a snowy January day.*

OPPOSITE: *The Beaver River meanders through the Beaver Valley to Thornbury, where it empties into Georgian Bay.*

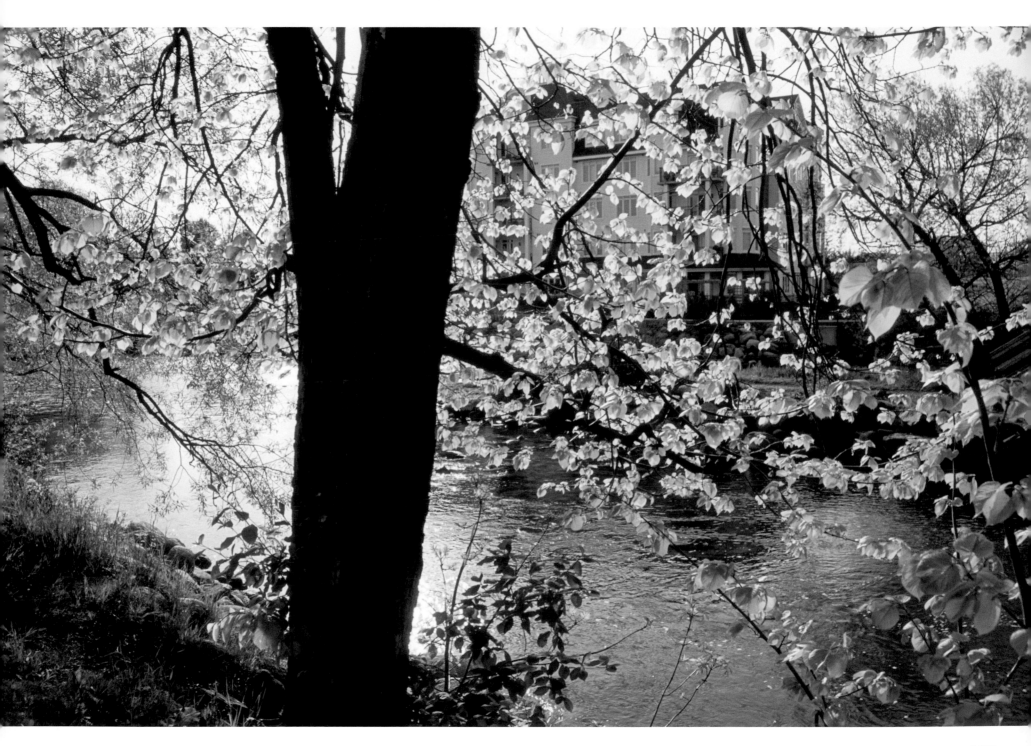

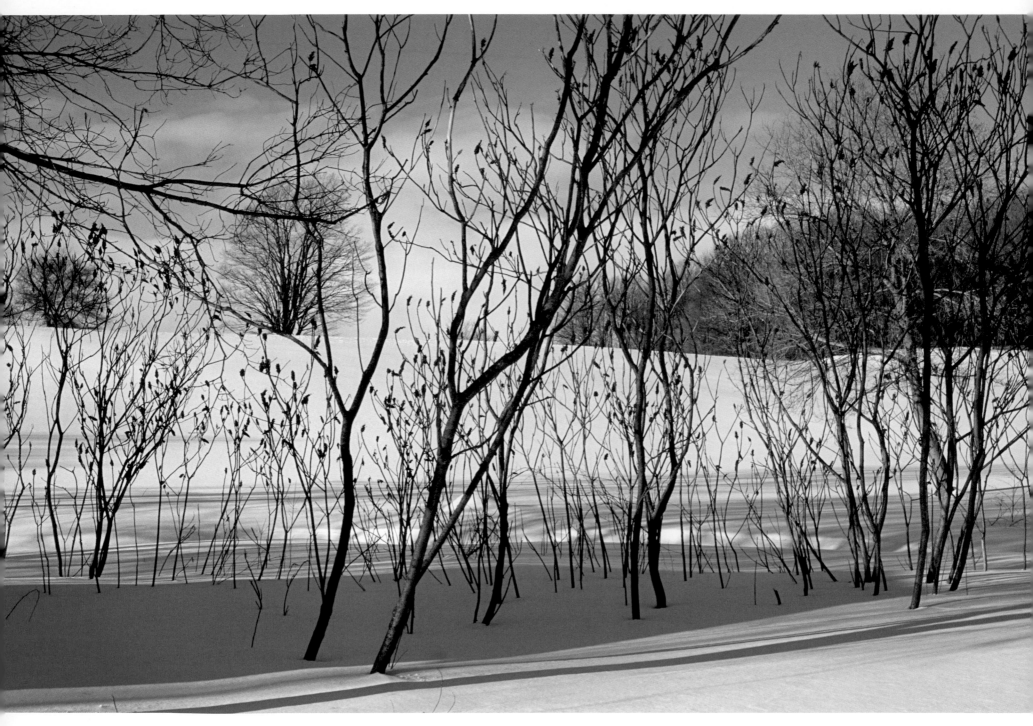

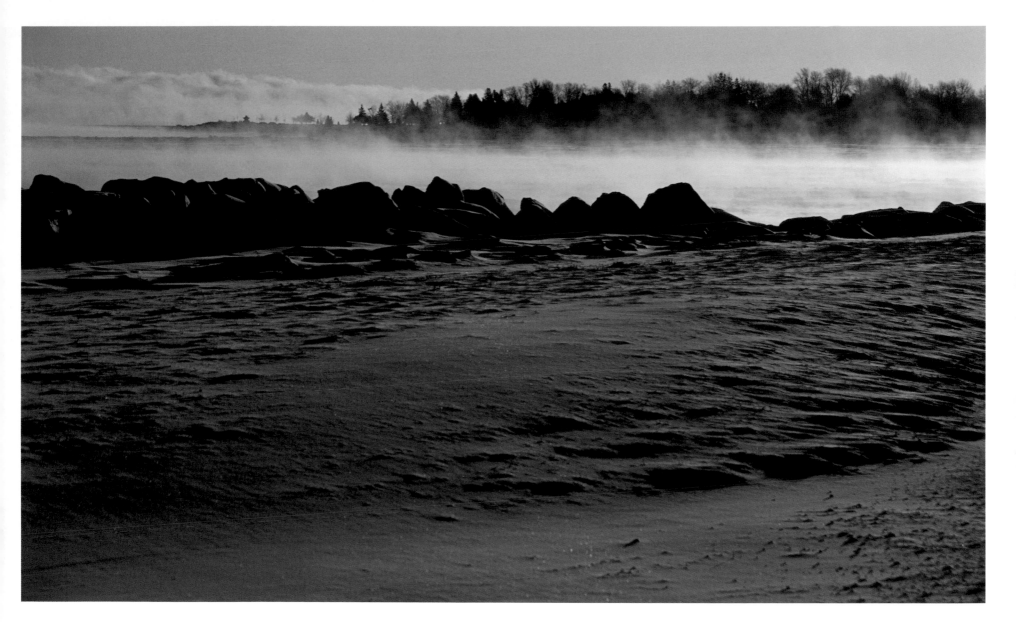

ABOVE: *Winter mist at sunrise in Harbourlands Park.*

OPPOSITE: *Winter shadows in a field near Creemore.*

In the book there's a wonderful watercolour portrait of Gordon, aged 11, scooping frozen lemonade out of a plastic container on the sunny back veranda of his home near Duntroon. "The combination of his summer tan, the August sun and the expression on his face," his father wrote, "seemed to me to be the essence of contentment."

Today, Gordon lives in the house with the sunny veranda, along with his wife and three children. He loves living here and, over the years, has lured many of his artist friends this way. "We were all living in the city," recalls Paul Mantrop, "but Gord had inherited the big old stone farmhouse after his dad died. We used to come up on weekends to the Art Farm, as he called it. He kept saying to us, 'You guys paint rocks, water and trees — Why are you in the city?' In the end most of us headed up here."

On a rainy night in October, there's a steady stream of people mounting the steep staircase up to the Level Gallery. They brush past a photo gallery of the Drawnonward artists at work and play. They are here for the opening of The Rob & Paul Show, an assembly of works by two of the group, Robert Saley and Paul Mantrop. The walls are crammed with paintings, including ones that celebrate the artists' recent journeys to the Canadian Arctic.

A live band plays softly in the background, patrons and friends drink wine, red stickers start to appear. Surveying the scene Paul Mantrop is enjoying himself. "One of the things I like best about having this gallery," he says, looking around at the high ceilings and stained glass windows, "is that the building has come full circle. In the late 1800s, it was a Masonic meeting hall. Now it's a place for gatherings of a different kind."

OPPOSITE: *Clouds roll in over Georgian Bay bringing changes of weather.*

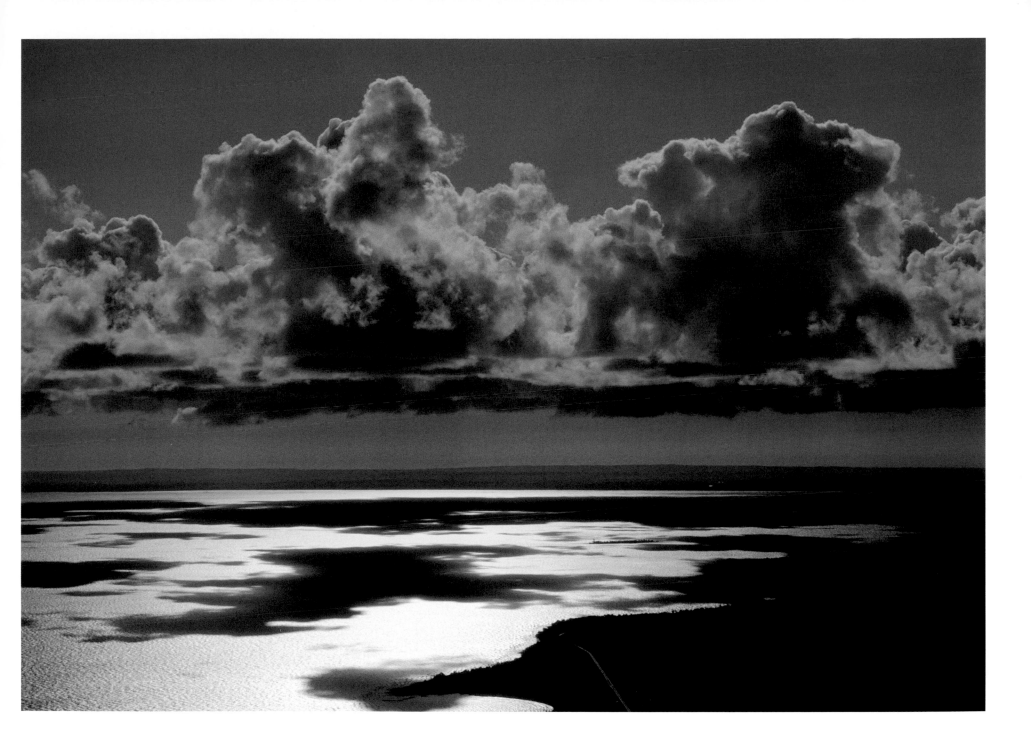

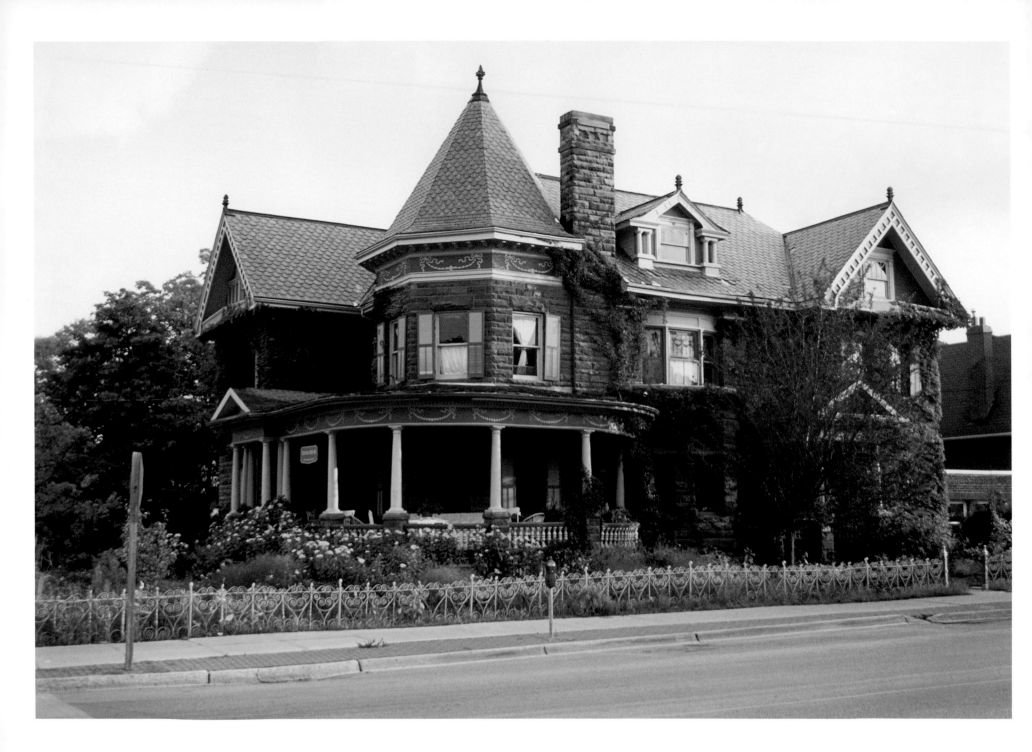

THIS PAGE: *The Olde Towne Terrace restaurant on Hurontario Street in Collingwood serves up special desserts.*

OPPOSITE: *Thurso House, designed in Romanesque revival style in 1902 by Collingwood architect Philip C. Palin. Now a Collingwood bed and breakfast.*

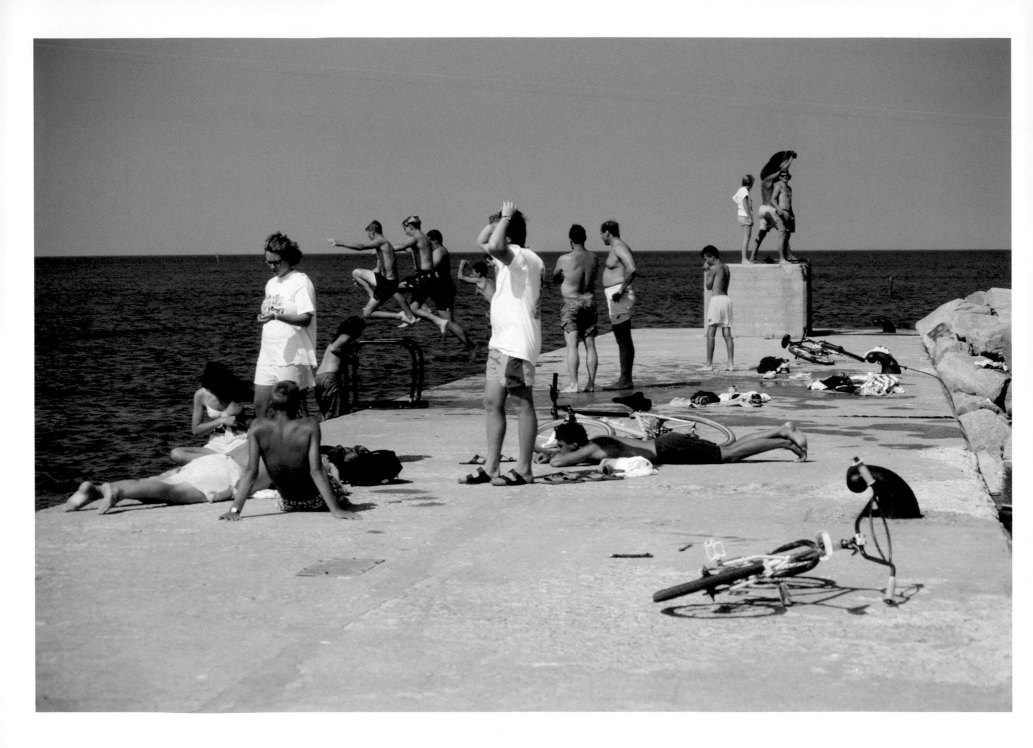

Thornbury, an Old-fashioned Town

11

O N A SUMMER EVENING the Thornbury harbour is lively with sailboats cruising in and out, children doing cannonballs from the wharf and music drifting down from the restaurant patio up the hill. Further along the shore the green parkland is filled with family groups enjoying the long hours of daylight. It's an idyllic scene, typical of life in this picturesque waterside village and far removed from its origins as a rough-and-tumble pioneer settlement.

Thornbury's early roots were as a mill town, which is not surprising considering its setting beside the Beaver River where it tumbles into Georgian Bay. The first settler, Solomon Olmstead, bought a block of land from the government in 1850 at the point where the river meets the bay. Seeing the potential for har-

nessing that river power, he set up a milling business. The three-storey building that was once his mill, the largest one on the Beaver River, is now the Mill Café, a restaurant with an outdoor terrace overlooking the dam and millpond.

Soon after Olmstead began his mill operation, the settlement began to thrive. By 1857 there were four hotels, a blacksmith shop, a general store, a post office and a hundred inhabitants. By the century's end the town had become an established port, providing settlers with processed wheat and wood as well as apple storage facilities.

An abundance of fish in the river and bay attracted fishermen, and a prosperous commercial fishing business began operating at the harbour. Today, fishing continues to be a big attraction. When the season opens in April, anglers come from all over and wade

OPPOSITE: *Midsummer at the harbour dock in Thornbury.*

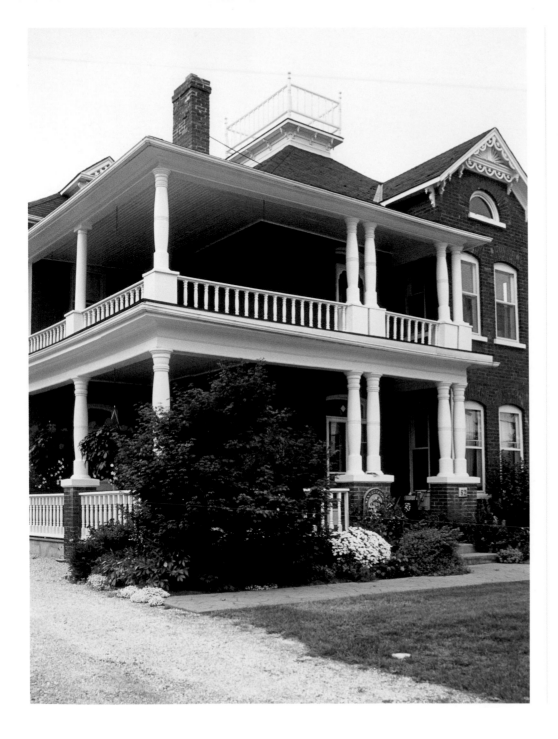

into the shallows at the mouth of the Beaver River casting about for rainbow trout. There's also a state-of-the-art fish ladder and dam, which was completed in 2003, allowing visitors to watch the salmon and lake trout as they travel from Georgian Bay upstream to their original spawning ground in the river.

A stroll up the main street is all it takes to appreciate the town's vintage charm. From the harbour it's a gentle climb past quaint stores and brick mansions, all well preserved, looking just as they did in the days when fishing and apple canning were the town's main occupations. Many of the houses have railed platforms on their roofs, known as widow's walks. It was from these perches that fishermen's wives looked out to the bay, most often on stormy nights, and hoped for their husbands' safe return.

LEFT: *A former sea captain's house, on Bruce Street in Thornbury, with a widow's walk on the rooftop.*

OPPOSITE:
Anglers wade into the shallows near Thornbury.

Night lights at the Thornbury dam and the Mill Café.

But perhaps the best way to experience the old-fashioned flavour of Thornbury is to come in early December when, on one special night, the main street turns into a scene from a Currier & Ives greeting card. Children are throwing snowballs, carollers standing beneath a doorway festooned with cedar swags are singing "Little Drummer Boy," and every store window in the old brick buildings is ablaze with lights and festive displays.

It's the annual get-together known as Olde Fashioned Christmas. Chestnuts roast on open fires and cleverly crafted ice sculptures line the sidewalks. The main street is blocked off so that town folk can meander about, greeting friends, sipping mulled wine and warming themselves around the large braziers that are crackling with wood fire in the middle of the road.

Held on the second Saturday in December, this annual celebration is the official kickoff to the holiday season. "It's really a community event," says Shiela Metras, a long-time Thornbury resident. "Its charm is in the fact that it is so low-key — it could only happen in a small town like this."

For children it doesn't seem low-key — it's a night of high excitement. They get to stay up late and watch the tree being lit in front of the Town Hall. They race around playing street hockey on the closed-off road. They eat far too many cookies and candies, which are liberally doled out in the shops. And they wait for Santa who arrives by sleigh along with a bevy of elves and a bagful of candy canes.

The whole event is a throwback to an earlier time — but then, Thornbury itself is a little like that — not just at Christmas but in every season of the year.

A house in Clarksburg, designed in 1969 as a replica of an American colonial saltbox.

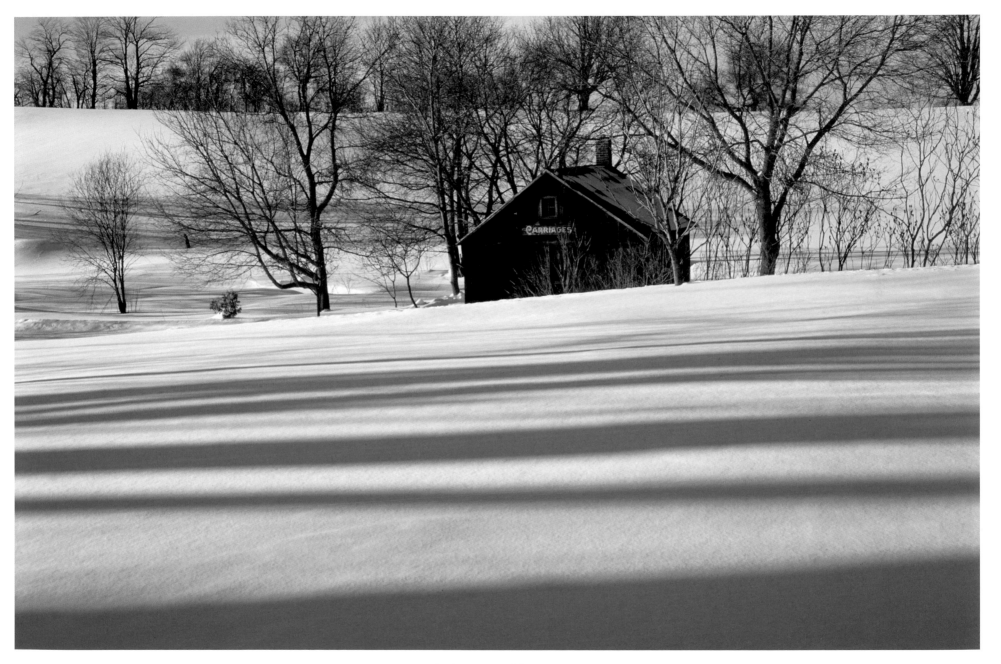

A vintage carriage shed, typical of farm property outbuildings.

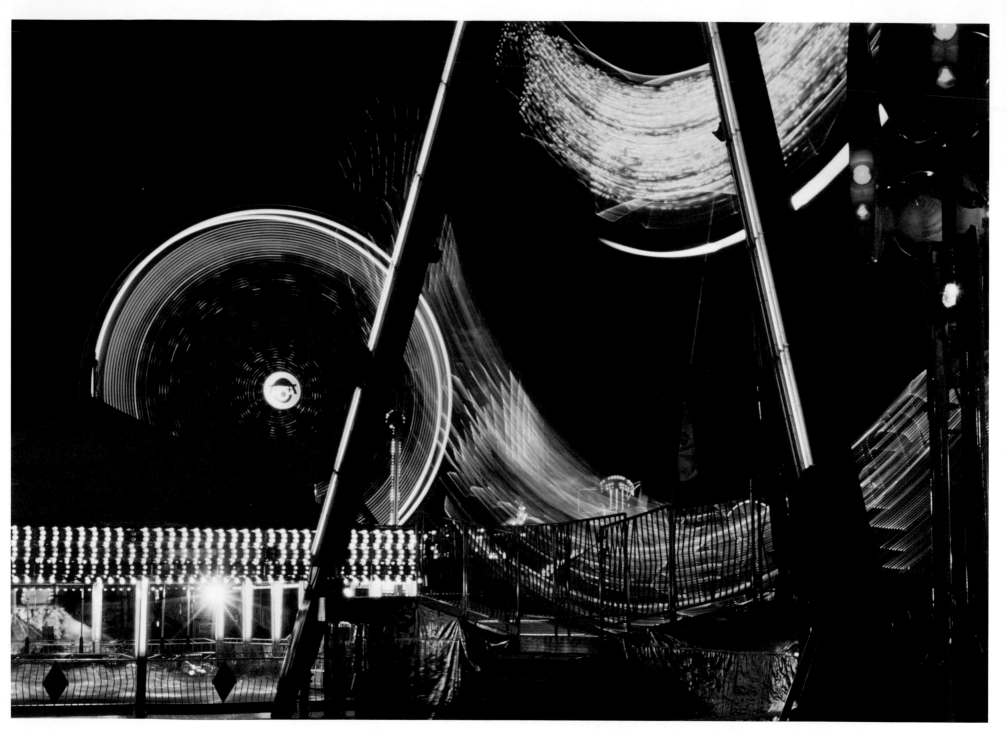

The Granddaddy of Fall Fairs

INSIDE THE BLUE TENT, the dusty air is speckled with bits of hay and ringing with the excitement of children's voices. "I like this one best," exclaims one knee-high youngster as he reaches into the pen to stroke the black face of a Suffolk ram. One loud "baaaa" and the child, who has never before seen a live sheep, jumps back to the safety of his dad's leg.

The ram happens to belong to Dan Needles, a well-known character in this area and award-winning author and playwright who penned The Wingfield Cycle, a series of plays that has been bringing life in the country to city audiences for many years. For the duration of this annual fall fair (the GNE, or Great Northern Exhibition), Needles the playwright takes back stage as he assumes the role of chairman of the

Sheep Show. He is one of hundreds of volunteers that keep this show on the road.

One of the mandates of agricultural fairs is to teach awareness to children who have never been on a farm, and this tent filled with sheep, goats and a few alpacas is one of many live animal exhibits. Aside from livestock there are fiddle and step dancing contests, antique car, truck and tractor shows, needlework displays, baby contests and demolition derbies — all forming the eclectic fabric of the area's most famous, and oldest, fair.

On this breezy September day, cars have been slowly streaming down the dirt lane to park in the open fields, far enough away that a big covered wagon is available to transport people back to the ticket booth. The fair sprawls over 47 acres and includes 30,000 square feet of indoor pavilions. Agricultural

OPPOSITE:

Nighttime thrills at the amusement park of the Great Northern Exhibition, one of the oldest continuously operating fall fairs in Canada.

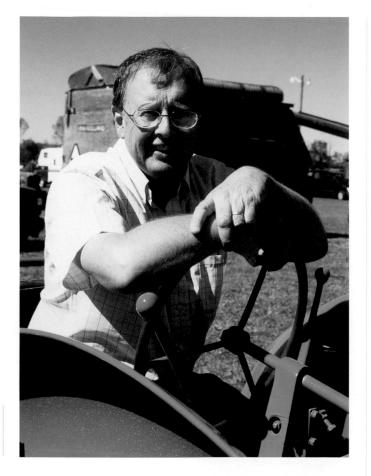

Author Dan Needles on his restored 1952 John Deere tractor.

bration, there is music and dancing and a raucous midway complete with a Ferris wheel, carnival games and melt-in-your-mouth cotton candy. For local residents this annual event is a trip back in time to the days when, as children, they were let out of school to march in the opening day parade. The parade is long gone, but the show goes on.

It was started in 1855 by the Nottawasaga Agricultural Society — basically a group of farmers — in a field outside Bowmore (now Duntroon), and despite world wars, depressions, and the loss of family farms, it has never missed a season. For a time the exhibition building was on Hume Street in Collingwood. Called the "Palace" it was a great wooden structure with ornate cupolas and elegant trim that looked more like a tycoon's overblown home than a shelter for farm animals and vegetable displays. It was rebuilt twice after arsonists torched it — the last time on Halloween night in 1908. The brick building on Hume that is now the Collingwood Curling Club served as the fair site for many years after that. Since 1984 it has been held on property owned by the Collingwood Agricultural Society on the 4th Line (Fairgrounds Road).

fairs like this exist in smaller versions throughout the area, all conceived by local agricultural societies to educate consumers on how food is produced and delivered to the dinner table. As such it is a combined event, serving as meeting place, exhibition, competition and educational resource. And because it's a cele-

Back in the sheep tent, the bleating continues while a grey-haired lady bends over a spinning wheel, demonstrating the old-fashioned process of creating thread from fleece and Don Metheral, Canada's national shearing champion, is hard at work. With his strong arms, he flips a hefty ewe into position and, in a few deft strokes, shaves off the thick white fleece, which drops onto the floor in piles around her now bare-skinned body.

Dan Needles is there too — "yammering away about sheep," as he says in typically self-deprecating fashion. Dan actually lives the rural lifestyle on a farm near Nottawa, with his wife, Heath, and four children, plus an assortment of pets and farm animals. His father-in-law gave him six sheep and a dog for a wedding gift 20 years ago, and he's had sheep ever since. "Including," he adds with a chuckle, "fifteen-year-old Butternut, the oldest ewe in Simcoe County."

Don Metheral, a champion sheep shearer, at work in the sheep tent at the Great Northern Exhibition.

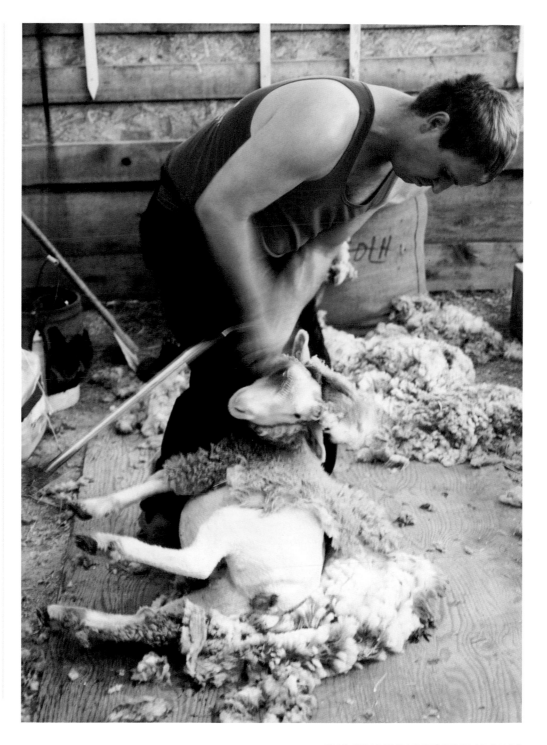

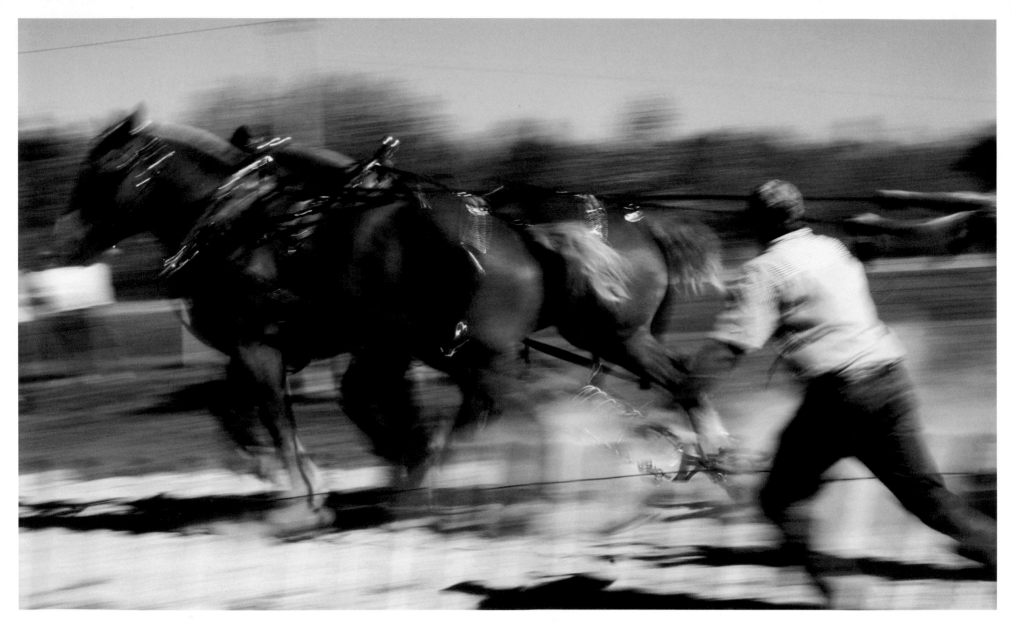

ABOVE: *The horse pull at the Great Northern Exhibition.*

OPPOSITE: *Equestrian events are held every August at the Collingwood Horse Show.*

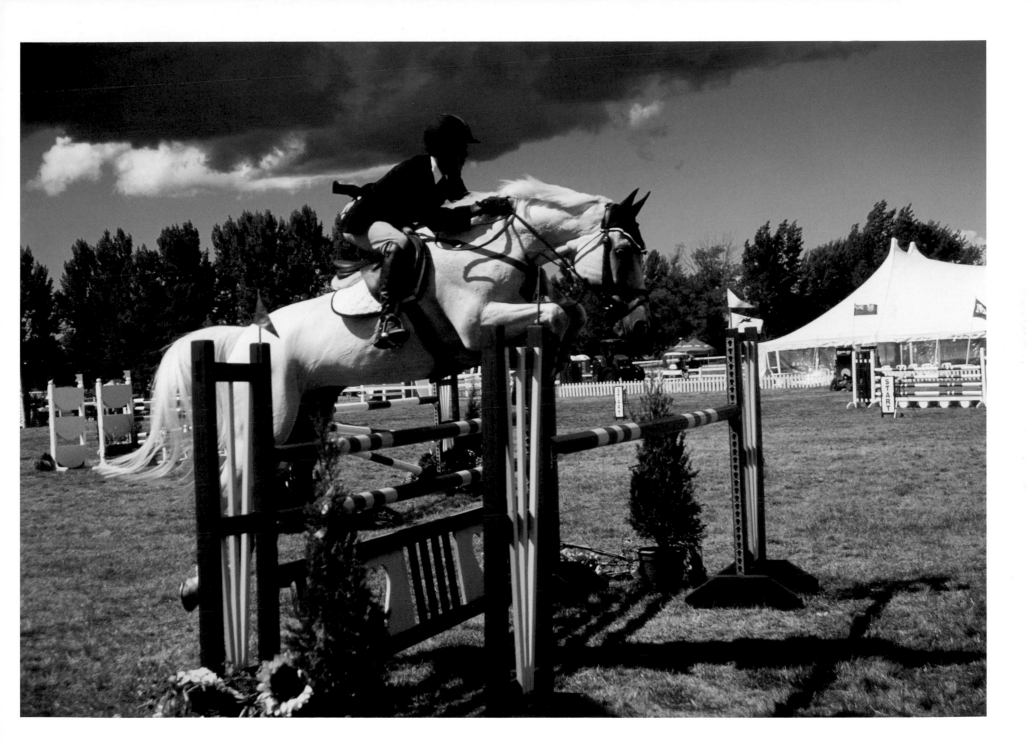

A Barn Reborn

<div style="text-align:right">13</div>

The interior of each barn may be admired for the majesty of its timbers, both horizontal and vertical, but more important is the vision of the interior exposed as a room in which the eye is drawn from the comparative lowness of one area to the more spectacular height of the central space, sometimes illuminated by cupola or clerestory.

Eric Arthur and Dudley Witney, *The Barn: A Vanishing Landmark in North America*

O N A BRIGHT NOVEMBER DAY, the view from the barn is of rolling meadows and a large pond surrounded by tall grasses waving in the golden sunlight. No animals live in this barn save for one, a dog named Bear, who is blithely curled up by the front door. But nevertheless this is a barn. A comfortable, bright, woodsy, quilt-filled space — but still a barn with its original time-worn honey-coloured timbers. At the very peak of the roof is the pulley that once lifted the hay loads, and the wooden ladder that accessed the loft is still built into the crossbeams in the living area. And the ultimate barn symbol — a diamond-shaped cut-out, the barn builder's signature created in 1891 — is now mounted inside on a wall beam above the kitchen entrance.

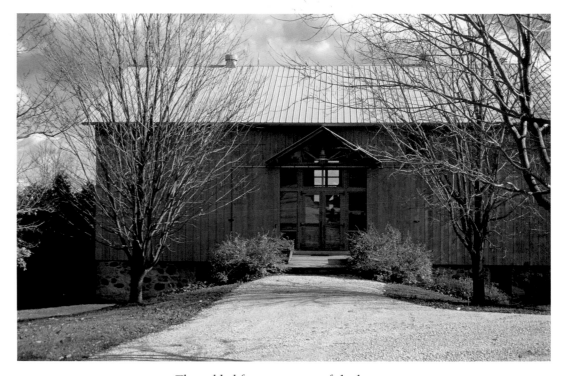

ABOVE: *The gabled front entrance of the barn.*
OPPOSITE: *A view across the pond of the Wright's restored barn.*

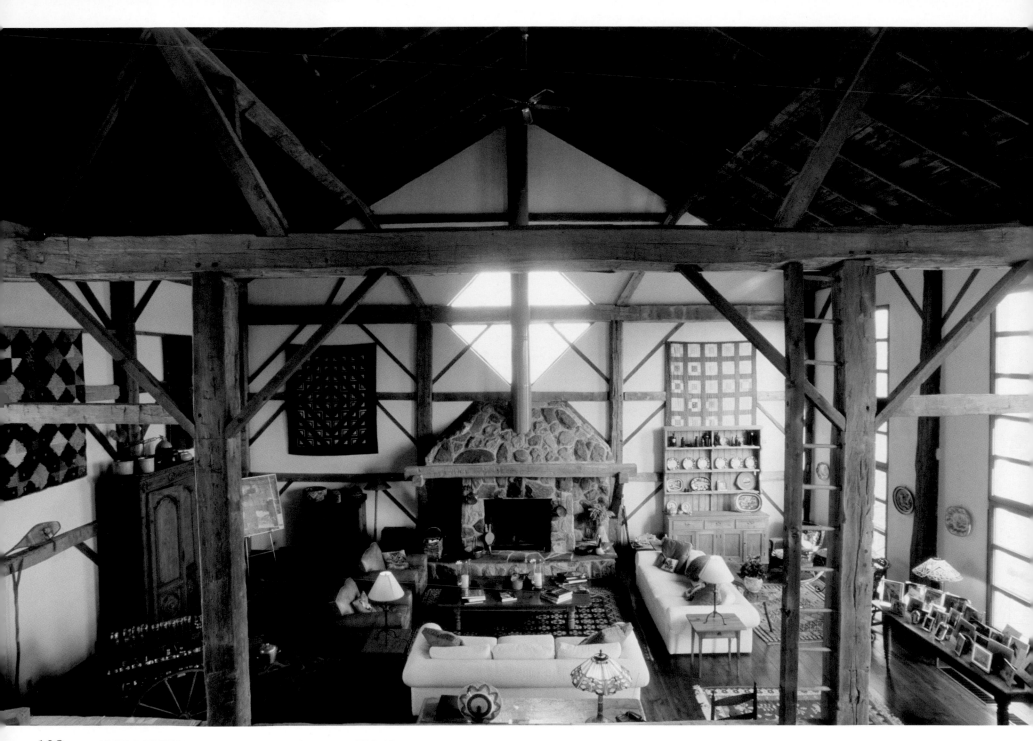

It was almost 30 years ago that architect Jamie Wright and his wife, Connie, used to drive by this 100-acre farm property every winter weekend on their way to ski at Devil's Glen Country Club. The land was lovely, gently sloping with a long-angle view toward the bay. But it was the old barn set back from the road that caught Jamie's eye. Back then all their friends spent winter weekends in rustic ski shacks — and nobody, except perhaps an architect, would have thought of living in a barn.

At one time barns like this were common all along the 10th Concession. Called banked barns, each was built on the side of a hill, with its long axis parallel to the hilltop. There was an entrance for animals on the bottom level and an upper level to store equipment and hay. In the early part of the twentieth century, every 100 acres supported a farm family. Many had come as pioneers, part of the large-scale settlement program that took place under the land grant system. So many were Scots that the nearby village (now Duntroon) was called Scotch Corners.

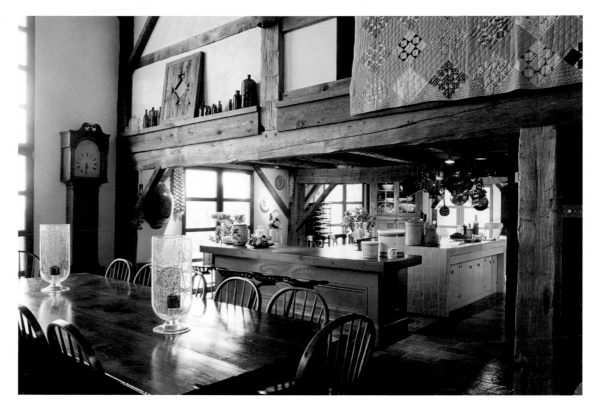

ABOVE: *Quilts hang from beams throughout the house.*

———

RIGHT:
The barn builder's signature.

———

OPPOSITE:
The main living area soars to the full height of the barn roof, and windows and doors are industrial size to fit the large scale of the space.

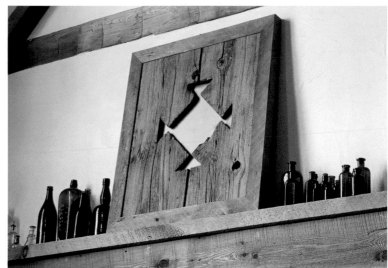

Jamie Wright had been fascinated with barns ever since he was a kid growing up in Truro, Nova Scotia, helping at his grandfather's farm and jumping from the barn's hayloft. He liked the simple geometric shape, the scale and proportion. And, with his architect's vision, he could imagine living in one.

By the time the Wrights bought the property, it had been on the market for two years. The old farmhouse had already fallen down, and tenant farmers had been keeping cows in the barn all winter. The first job was to remove 3 feet of manure and power wash all the beams to get rid of a hundred years of grime. They then removed all the exterior cladding, insulated it "like crazy" and put up new wallboards and tin roofing. One of the lucky discoveries was that the building was almost perfectly square — a result, they learned, of the animals keeping it warm all winter and keeping frost out of the footings.

Although the Wrights first envisioned the barn as a ski chalet for winter use, they soon discovered the beauty and comfort of being here in all seasons. "It's like living in a great outdoor pavilion," enthuses Jamie. "The barn is almost religious in scale." Then he adds with a smile, "I sometimes think I should build a brick bungalow close to the road, with big windows, and put animals in it."

LEFT: *Salvaged tractor seats serve as bar stools at an antique store counter in the kitchen.*

ABOVE: *The ski hills in autumn.*

OPPOSITE: *The soft green of spring at a farm in the Beaver Valley.*

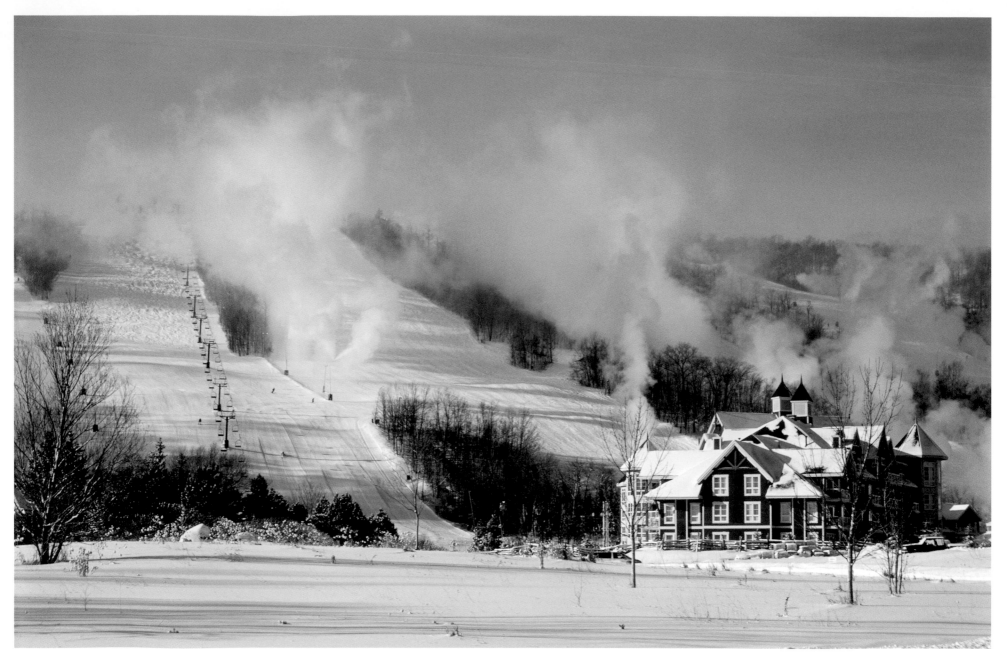

Snow blowers create artificial snow to keep slopes well covered throughout the season.

Jozo's Blue Mountain

<div style="text-align: right">14</div>

FEBRUARY 2007. Winter has finally arrived. After a shockingly green start to the ski season, the hills are now beautifully white, and skiers and snowboarders are cruising down the slopes at Blue Mountain, Ontario's largest downhill ski resort. Much depends on snow here, and sub-zero temperatures are required for snow-making machines to churn out the artificial stuff that coats the hills when Mother Nature hasn't provided. When dark snow clouds come lumbering over Georgian Bay, they're as welcome as the groundhog's proverbial shadow.

It's close to lunchtime on this overcast winter day, and skiers are swooshing to a stop, lifting off their helmets, locking up their skis and clomping into the Village at Blue to seek out a friendly pub. This lively enclave, based on the already successful models devel-

oped by Intrawest Corporation at Mont Tremblant in Quebec and Whistler in British Columbia, consists of upscale condos, boutiques, cafés and a pedestrian-friendly square where skiers gather around a firepit to warm their cold hands. The Village was started in 1999

Skiers coming off the chairlift at the top of Blue Mountain.

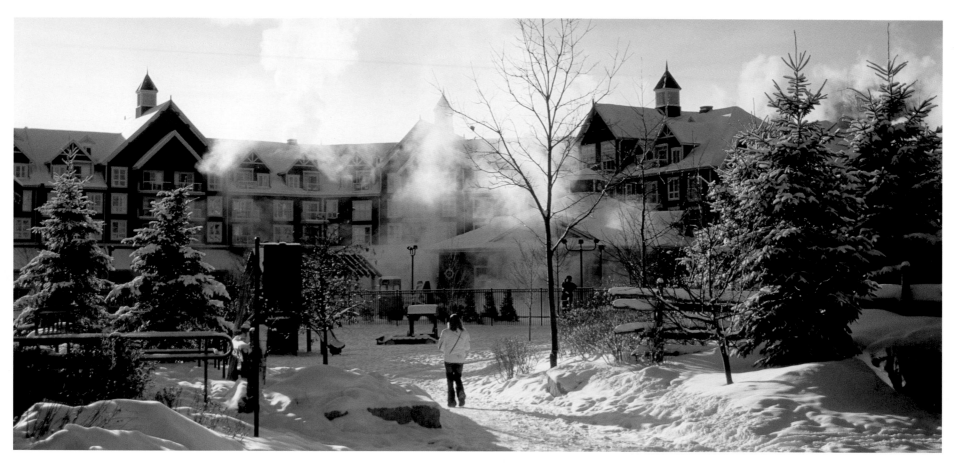

and has grown every year since, adding more hotels, more stores, more restaurants — with a plan to be completed by the year 2011.

"This was once a hayfield," says George Weider, who is chairman of Blue Mountain Resorts Ltd. and still in awe of the transformation as he wanders through the crowded Village square. "I used to help my father farm these fields."

Jozo Weider, George's father, is commonly regarded as "Mr. Blue Mountain." He arrived here in 1941 from what was then Czechoslovakia at a time when the ski hills were first being carved off the face of the Niagara Escarpment. By the 1950s he had become a colourful figure, the ubiquitous man in charge. Anyone who skied at Blue Mountain at that time will remember him yodelling on the hilltops and ladling

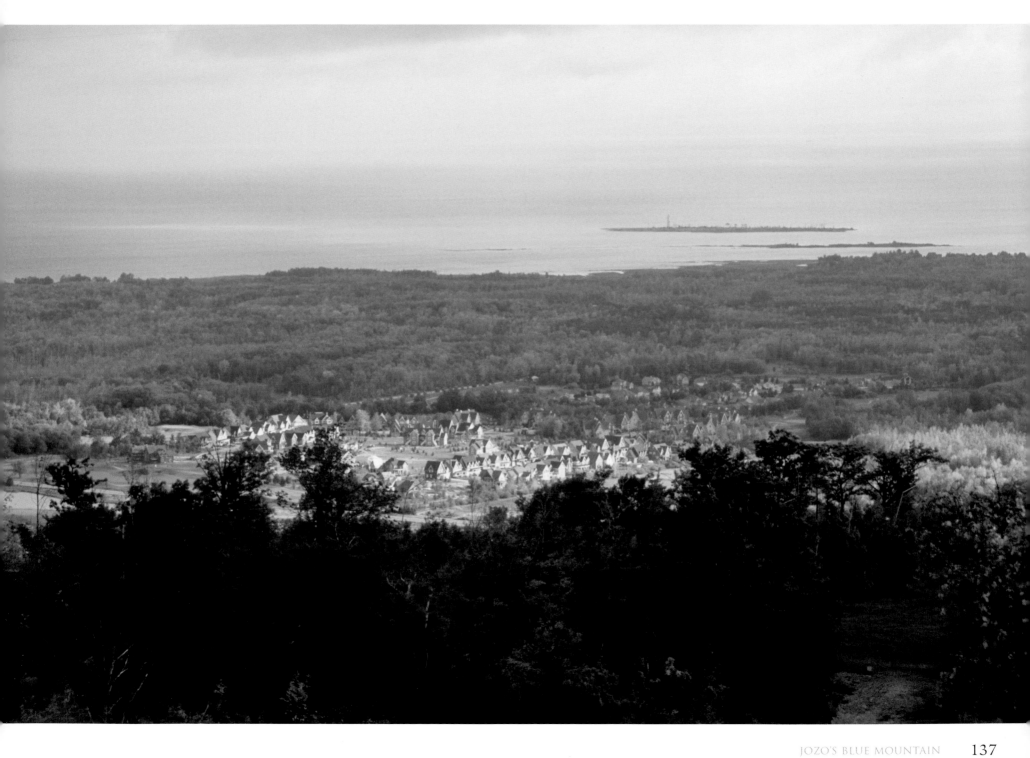

The carfree Village at Blue is like a European town square where everyone gathers.

wheel outfitted with small light bulbs provided cozy lighting, and on many nights square dancers were do-si-doing around the sloping dance floor. With Jozo in charge, the ski experience at Blue Mountain was as exotic as it got in staid 1950s Ontario.

Jozo Weider was born in 1908 in the Slovak part of what later became Czechoslovakia. By the 1920s he had built a ski chalet in the mountains and lived there throughout the 1930s, making a living as an innkeeper, a mountain guide and a photographer. He was in England promoting his ski chalet when the Nazis occupied Czechoslovakia in 1939. Jozo never returned to his chalet; instead he emigrated to Canada with his wife, Helen, and baby son, George. They moved first to the Peace River region of British Columbia and then to Quebec, where Jozo worked as a ski instructor at the Alpine Inn, in Ste-Marguerite.

out chili at the base of the hills. Then, after the tows closed, he kept the party going inside the old ski barn.

The atmosphere there was part Ontario barn, part European chalet. Weathered wooden beams supported walls that were painted with bright folk art, wood smoke wafted from the large fireplace, and singers leaned over a second-floor balustrade as Jozo played his accordion down below. A large yellow wagon

The village viewed from across the pond at dusk.

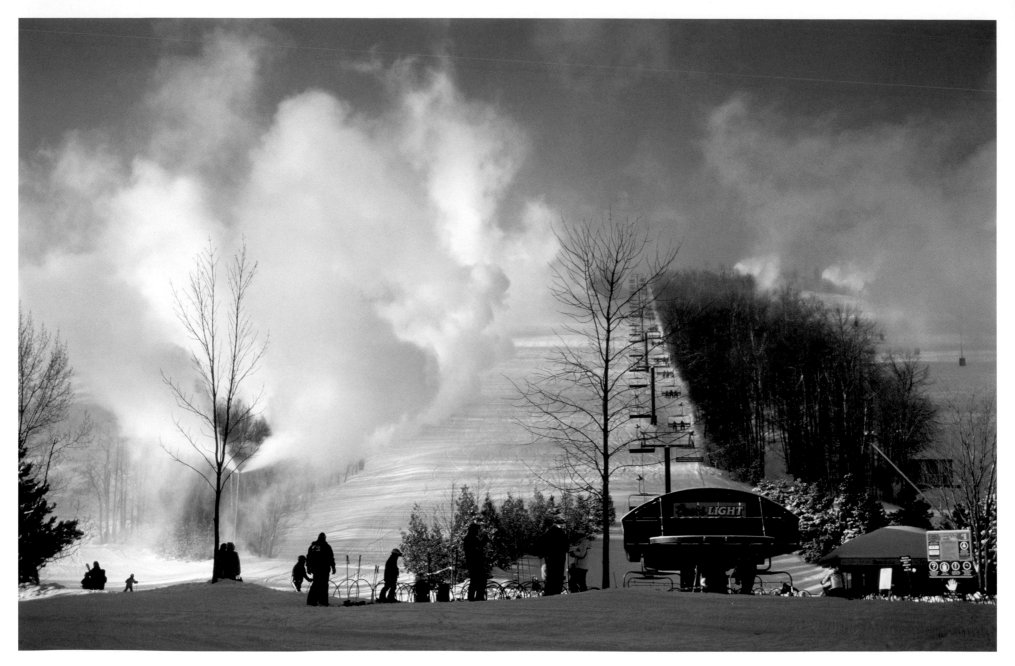

Skiers head up Tranquility on the Silver Bullet chairlift.

While there, he met Peter Campbell, who was involved in developing ski areas in Collingwood. The two started a partnership to develop Blue Mountain, and the Weider family moved into a farm at the base of the escarpment. From that day on, Jozo Weider devoted himself to giving visitors a great ski experience.

The ski barn is long gone and Jozo died in a car accident in 1971, but his son George remembers him as "a great visionary" who would be pleased with the growth and transformation. The Weider family is still involved in running the resort in partnership with Intrawest, and this season they celebrate its 65th anniversary, with 13 lifts, including four high-speed six-person chairs and 34 trails spanning the escarpment face. In honour of this milestone, the Pontiac Grand Prix chair at the north end of the resort has been renamed the Jozo Weider chair. Just one more way that Jozo's name will be forever enshrined at Blue Mountain.

Blue Mountain Pottery ceramic pieces, once produced here, are now collector's items.

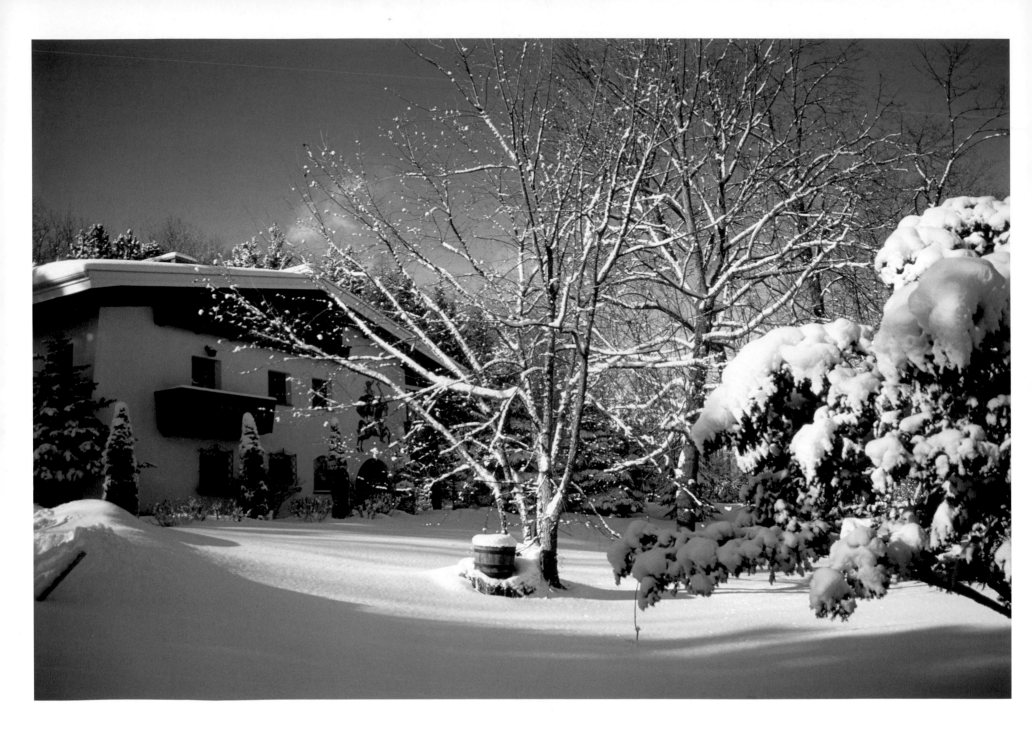

THIS PAGE: *A collection of roosters, folk art and hand-painted European furniture enliven the interior of the Weider home.*

OPPOSITE: *In the late 1960s, a Czech architect designed this chalet-style home at the south end of Blue Mountain for Jozo Weider. It is now the home of Jozo's son George Weider and his wife, Barbara.*

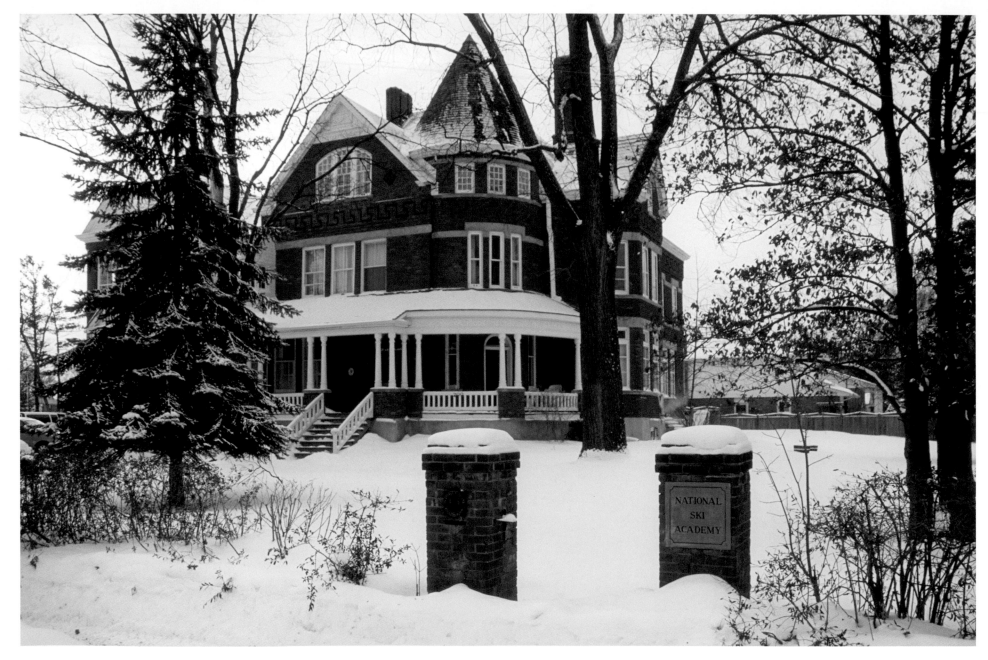

Tornaveen, on Oak Street in Collingwood, home to the National Ski Academy.

Tornaveen

S TATELY HOMES are not unusual along Third Street in Collingwood. Elaborate brick mansions, designed in the Queen Anne Revival style, were built in the years between 1880 and the early 1900s, when the town was booming and the harbour trade was creating a prosperous class of merchants, all of them anxious to show off their new-found wealth. Both Third and Minnesota streets were favoured locations for their showy homes. One such place stands at the corner of Third and Oak streets, and although once known as Tornaveen, it is now the National Ski Academy, home to athletic youngsters who dream of becoming Olympic skiers.

The interior of the 14-bedroom house is so lavish that in 1893, just after it was built, the local press claimed it was "good enough for a prince." Today it is simply home to the young people who live here during the school year. In the high-ceilinged bedrooms with their bevelled-glass windows, kids sprawl across beds, typing out essays on their laptops. Ski posters and school timetables are plastered above the wainscotting. Downstairs, a group watch a video of their performance on the ski hills, oblivious to the ornate ceiling medallions and richly panelled mahogany walls.

It took a committed board of directors and many private donations to promote the concept of the Ski Academy, buy the old house and refurbish it. The academy opened in 1986, and ever since it has run a program that combines academic subjects and alpine ski racing training. Patterned on traditional European and American sports academies, the National Ski Academy takes in 25 to 30 students every year. They come from across Canada to live, train and receive an education.

When Tornaveen was built in 1892, the area ski hills didn't even exist, but the town's position as a strategic port facility on the Great Lakes led many to believe that it would become the "Chicago of the North." Mansions were popping up everywhere. But Tornaveen, with its four ornamental chimneys, conical turret and masses of windows, was the tallest and most conspicuous of them all.

It was built by Frank Telfer, the 38-year-old mayor of Collingwood. His wealth came from the family business, Telfer Brothers, a wholesale biscuit-manufacturing company. Determined to live in a home that reflected his importance in the community, he bought five town lots and hired the town's leading architect, Fred T. Hodgson, to design a home with 10,000 square feet of living space. He wanted it to be larger and showier than his brother Herbert's house, Armadale, across the street.

For a while in the early 1900s, the Telfer brothers' homes provided the hub for society activities in Collingwood. Elaborate parties were held in the richly decorated drawing rooms, and when visiting dignitaries came to town, they were feted in the gardens of Armadale and Tornaveen. But these heady days came to an abrupt end in 1924 when the Bank of Toronto called its loan and

Old-time ski chalets at Blue Mountain were once known by their quirky names.

the Telfer brothers lost the family business. Soon after, Frank Telfer sold Tornaveen.

Ironically, children were the next group to occupy this enormous house when it became the Gowans' Home for Missionaries' Children. Its new role was to provide a "stable Christian home" for the offspring of missionaries posted overseas. Until the mid-1960s, both Armadale and Tornaveen were filled with these youngsters. But then, when missionaries began taking their children with them to foreign postings, the need for such places ended. Tornaveen sat empty and derelict for years.

Today, the house is once again filled with youngsters. It is still a splendid house with its rich architectural features intact, but instead of brocade sofas and Persian carpets, the house is furnished with castoffs and donations from the academy's many supporters. And instead of resounding with the chatter of society gatherings, the house echoes with the liveliness and energy of Canada's future Olympic skiers.

OPPOSITE: *An inukshuk on the road from Old Baldy overlooks ski slopes in the Beaver Valley.*

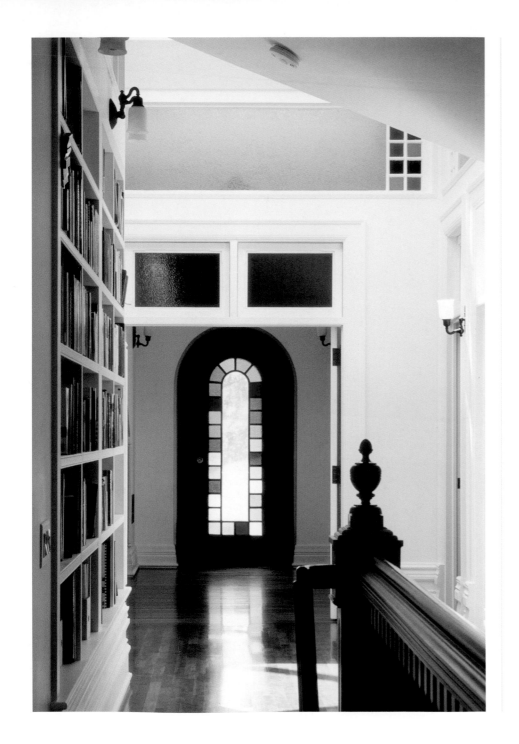

THIS PAGE AND OPPOSITE: *Built in 1889, this grand Regency-style cottage occupies a large lot on Minnesota Street in Collingwood. The lavish interior carpentry is the work of the original owner. A recent restoration has captured the home's splendour.*

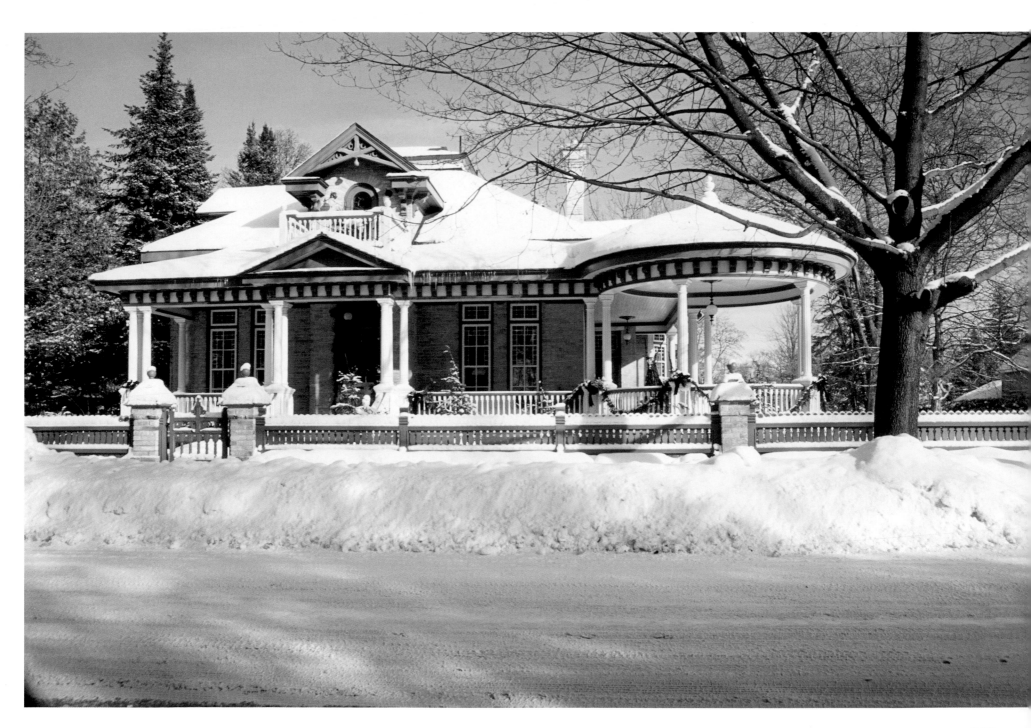

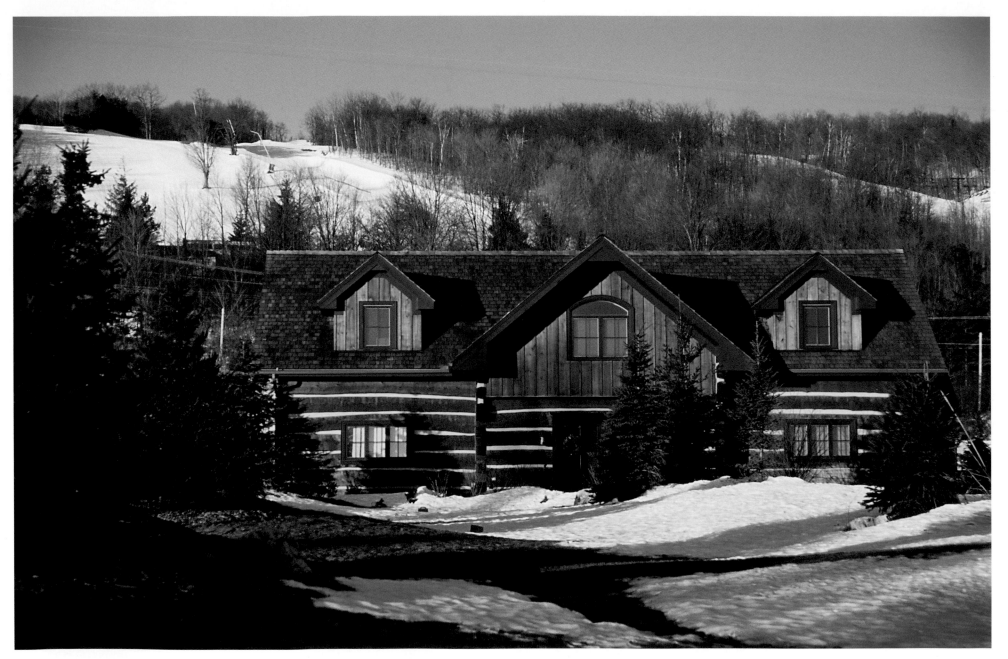

The slopes of Osler Bluff Ski Club form the backdrop to this square-timbered log home.

A Log Home for the Holidays

16

I T'S CHRISTMAS TIME. Snow is billowing outside the windows, whitening the landscape and giving hope to skiers who have come north for the holiday season. The night air is brisk, but inside the hand-hewn log home, there's a fire in the stone fireplace, candles on the mantle and a decorated spruce tree twinkling in the corner. The scent of roasting turkey fills the air.

The homey scene is repeated all across the Blue Mountains, where cabins and chalets fill with family and friends who come to ski on winter weekends — and settle in for a longer stay over the Christmas holidays. These chalets, built in clusters around the various ski clubs, are increasingly designed with massive high-ceilinged great rooms and enough space to house a small village, but the ones that seem most suited to the snowy Georgian Bay winter are those made of logs.

The tradition of log building in this area dates back to the humble dwellings of pioneer days. Early settlers constructed sturdy houses using trees they felled when clearing the land. Collingwood's

The dining table, made from old barn boards, is surrounded by classic black Windsor chairs.

oldest surviving house is a log cabin built in 1853 and dubbed, cutely, Kozy Korners. It faces the water at Sunset Point, and although added to and renovated over the years, it still features the traditional square-cut logs with dovetailed corners and a single gable above the front door.

Historic cabins like this were modest, often one-room dwellings, and many have since disappeared, torn down to make way for more modern constructions. Instead of valuing its craftsmanship, people viewed the log cabin as a "poor man's shack" and — if they did not demolish it — covered it up with roughcast stucco. As a result the art of log building — the ability to create hewn logs out of tree trunks and fit them squarely together with chinking — almost disappeared.

A renewed interest in handcrafted log houses or "loggies," as they're affectionately called, came about in the late 1960s, a time when half-acre building lots could be had for a song at the base of Blue Mountain and private ski clubs were parcelling off lots to club members. The ski chalets tended to fall into distinct categories: they were either rustic shacks or looked like something from the European Alps, with white stucco walls, carved wooden balconies and decorated shutters. And some were made of logs — sometimes transported from other parts of Ontario and rebuilt log by log on site.

Hand-hewn logs and custom-made newel posts
add character to the staircase.

Ready for the holidays with a blazing fire, plenty of candles and a brightly lit spruce tree.

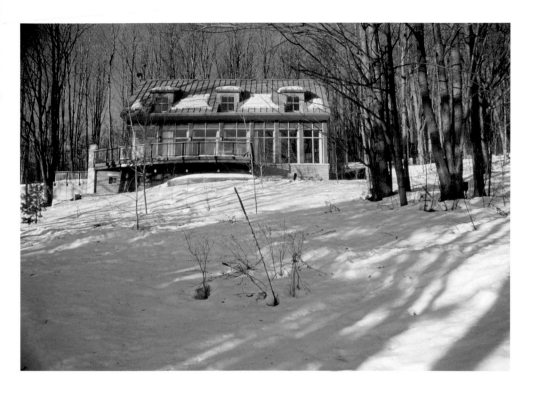

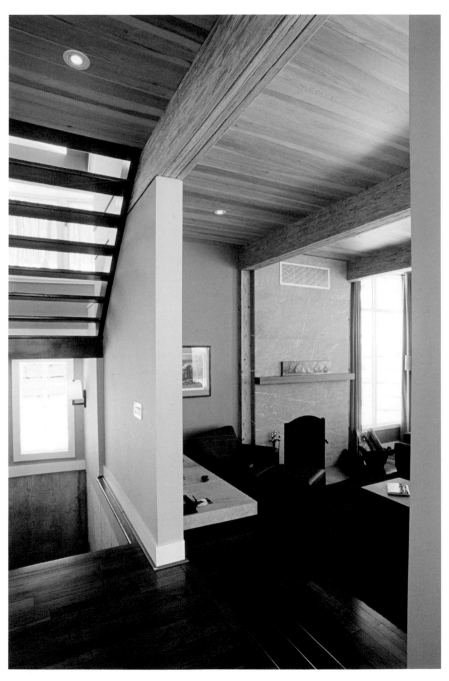

ABOVE: *Ski cabins have come a long way from
the A-frames and Swiss chalets of decades past.
This contemporary weekend home, designed by architect
John Robert Carley for a family of skiers, features a stone base,
walls of windows, a tin roof and shed dormers.*

OPPOSITE AND RIGHT:

*The minimalist interior, built on several levels,
has gleaming wood floors and vaulted ceilings.*

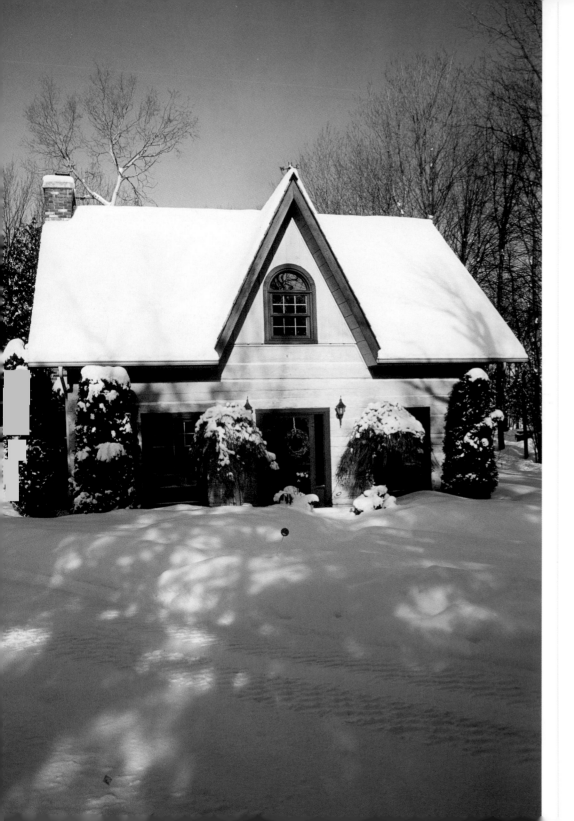

Today, the log-building renaissance continues with a multitude of new "pioneer-style" log homes providing steady business for log builders based around Blue Mountain. "I'm a big fan of cozy," enthused one owner, whose cabin is hidden in the woods near Craigleith. "I think anyone who lives in a log home will understand this." This coziness comes, in part, from the insulating quality of the wood. Thick pine keeps the house warm in winter and cool in summer and makes the entire place smell like the middle of a forest. Their owners tend to furnish in rustic style, with early pieces of Canadiana, plenty of warm-coloured carpets and wall hangings. Oversized sofas and armchairs are a joy to sink into on a cold winter's night — and an ample coffee table stacked with books and candles offers feet-up comfort after a day on the slopes.

As the turkey is carved, the family crowds around the long harvest table, wine glasses in hand, to toast the season. The children are quiet, playing with new toys on the floor. Snow is falling outside. And dogs are snoozing in the warm glow of the fireplace. It's a comforting old-fashioned scene — one that could have been lifted from a Cornelius Krieghoff painting.

The author's log home, south of Collingwood,
on a bright winter's day.

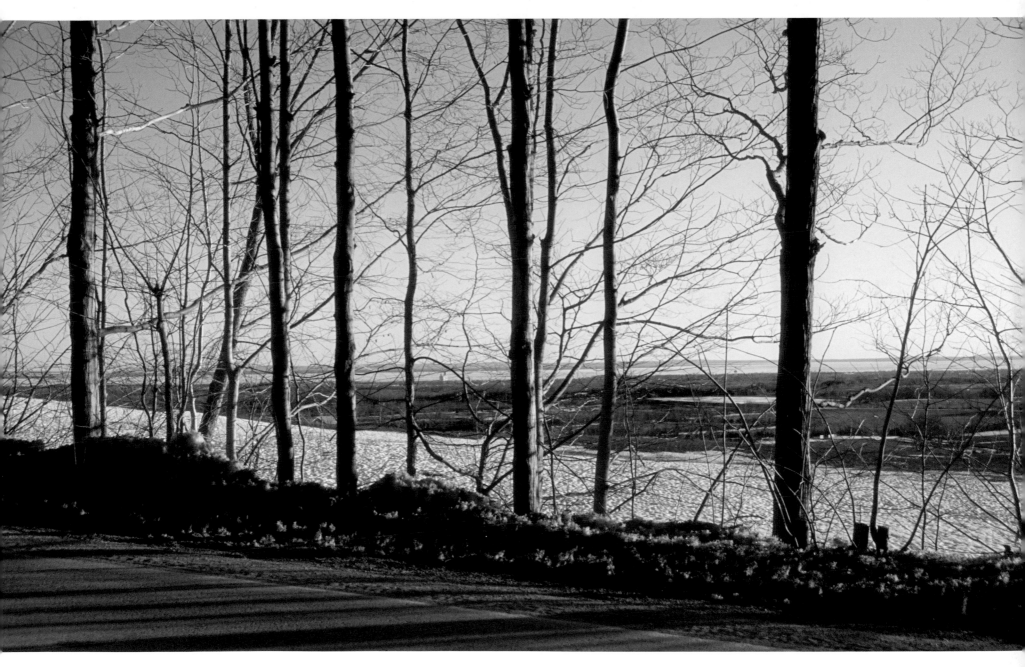

A view of the bay near the end of winter.

Bibliography

Arthur, Eric, and Dudley Witney. *The Barn: A Vanishing Landmark in North America*. Toronto: McClelland & Stewart, 1972.

Barry, James. *Georgian Bay: The Sixth Great Lake*. Toronto: Clarke, Irwin, 1968.

Brazer, Marjorie Cahn. *The Sweet Water Sea: A Guide to Lake Huron's Georgian Bay*. Manchester, Mich.: Heron Books, 1984.

Collingwood Centennial Committee. *The Story of Collingwood: 100 Years, 1858–1958*. Collingwood, Ont.: Enterprise-Bulletin Presses, 1958.

Cruickshank, Marie. *Come to the Fair: A History of the Great Northern Exhibition, 1855–2005*. Collingwood, Ont.: Collingwood Agricultural Society, 2005.

Gillham, Skip. *The Ships of Collingwood: Over One Hundred Years of Shipbuilding Excellence*. St. Catherines, Ont.: Riverbank Traders, 1992.

Hodson, Nick. *A Collingwood Collection: Drawings*. Collingwood, Ont.: Blue Mountain Foundation for the Arts, 2002.

Kemp, Robert G. *Robert G. Kemp's Paintings and Drawings of Rural Ontario: A 25-Year Retrospective of the Artist's Works*. Collingwood, Ont.: Blue Mountain Foundation for the Arts, 1983.

Lane-Moore, Laurel. *Collingwood: Historic Homes and Buildings*. Collingwood, Ont.: Blue Mountain Foundation for the Arts, 1989.

Miles, Anita. *The Chicago of the North*. Collingwood, Ont.: Town of Collingwood, 2004.

Order of the Eastern Star. Bon Accord Chapter No. 247. *"Know Collingwood": Industrial Centre, Summer and Winter Playground*. Collingwood, Ont.: Bon Accord Chapter No. 247, Order Eastern Star, 1950.

Purple Hills Arts & Heritage Society. *A Green and Pleasant Place: A Glimpse of Creemore and Area*. Creemore, Ont.: Purple Hills Arts & Heritage Society, [1998].

Wells, Kenneth McNeill. *Cruising the Georgian Bay*. Toronto: Kingswood House, 1958.

Weider, George. *Blue Mountain*. Erin, Ont.: Boston Mills Press, 1990.